TOUCHSTONE *200 Years of Artists' Lithographs*

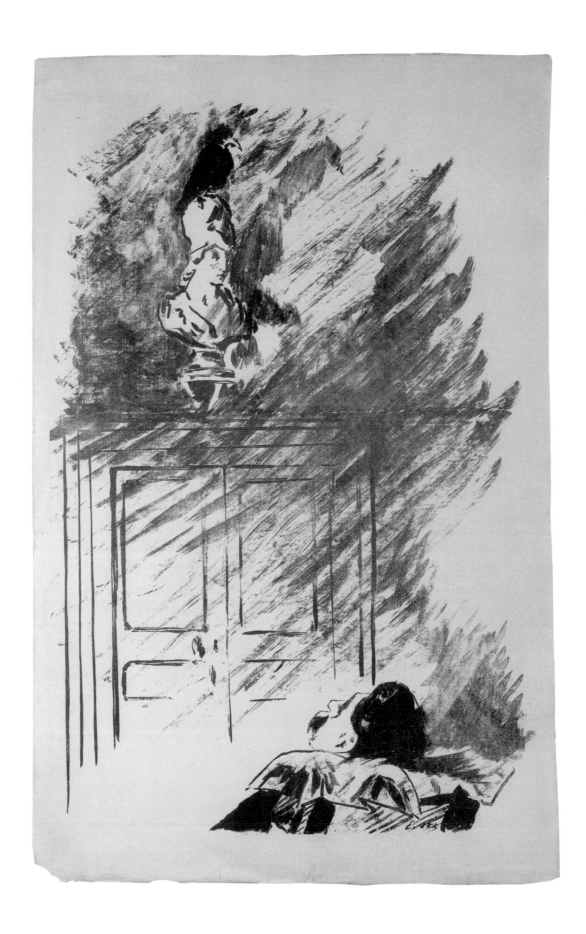

Marjorie B. Cohn and Clare I. Rogan

TOUCHSTONE *200 Years of Artists' Lithographs*

Harvard University Art Museums

CAMBRIDGE, MASSACHUSETTS

Touchstone: 200 Years of Artists' Lithographs is the catalogue of an exhibition organized by the Harvard University Art Museums, Cambridge, Massachusetts. This catalogue has been made possible by generous support from Albert H. Gordon.

Exhibition tour:

Arthur M. Sackler Museum
Harvard University Art Museums, Cambridge
15 August – 1 November 1998

University of Michigan Museum of Art
Ann Arbor, Michigan
17 July – 26 September 1999

Agnes Etherington Art Centre
Queen's University, Kingston, Ontario, Canada
30 September – 10 December 2000

Ackland Art Museum
University of North Carolina, Chapel Hill, North Carolina
4 February – 13 May 2001

Illustration copyrights:
Front cover, © James Kelly; figs. 4, 5, © Estate of Reuben Kadish; fig. 12, © Tetsuya Noda; figs. 13, 34, 35, © Artists Rights Society (ARS), New York/ADAGP, Paris; fig. 14, © Blumarts, Inc., courtesy Peter Blum Edition, New York; fig. 15, © Joyce Wieland; figs. 36, 37, © Willem de Kooning Revocable Trust/Artists Rights Society (ARS), New York; fig. 41, © Ellsworth Kelly; fig. 42, © Rudy Pozzatti.

Library of Congress Cataloging-in-Publication Data
Cohn, Marjorie B.
 Touchstone : 200 years of artists' lithographs /
 Marjorie B. Cohn and Clare I. Rogan.
 p. cm.
 Catalog of an exhibition held at the Arthur M. Sackler Museum, Harvard University Art Museums, Cambridge, Aug. 15–Nov. 1, 1998, University of Michigan Museum of Art, Ann Arbor, July 17–September 26, 1999, the Agnes Etherington Art Centre, Queen's University, Kingston, Ontario, Canada, Sept. 30– Dec. 10, 2000, and the Ackland Art Museum, University of North Carolina at Chapel Hill, Feb. 4–May 13, 2001.

 Includes bibliographical references and index.

 ISBN 0-916724-99-9 (alk. paper)

 1. Lithography — Exhibitions. I. Rogan, Clare I., 1968– .
 II. Arthur M. Sackler Museum. III. University of Michigan Museum of Art. IV. Agnes Etherington Art Centre.
 V. Ackland Art Museum. VI. Title.
 NE2260.W18A783 1998
 769' .074 — dc21 98-35410
 CIP

FRONT COVER:
James Kelly, *Red Wednesday*, no. 51

BACK COVER:
James Abbott McNeill Whistler, *The Beautiful Sleeping Lady*, no. 93

FRONTISPIECE:
Edouard Manet, *The Raven on the Bust of Pallas Athena*, no. 56

Contents

7 Foreword
James Cuno

9 Acknowledgments

11 Introduction
Marjorie B. Cohn

15 The Artist's Touch
Marjorie B. Cohn

37 Drawing Lithography: Originality and the Graphic Sign in France and England, 1798–1830
Clare I. Rogan

61 The "Freedom and Extravagance" of Transfer Lithography
Marjorie B. Cohn

83 Checklist of the Exhibition

93 Works Cited in the Checklist

95 Index

Foreword

The history of lithography, perhaps more than that of any other printing technique, has been one equally of technological advancement and artistic and commercial application. Lithography was invented in 1798, as a way of more easily reproducing musical scores and the texts of plays (its designs are drawn by hand on a matrix, usually limestone, much as one draws on a piece of paper, whereas engraving and etching, for example, require cutting into metal plates or eating into them with acid).

Within a short time, its inventor, the Bavarian Alois Senefelder, joined forces with the music publisher Johann André and his sons Frédéric and Philippe to enter patent claims for the technique in Berlin, Vienna, Paris, and London. Their ambition was to secure markets for lithography in matters both commercial and artistic: for advertising circulars, engineering blueprints, wallpaper, and all manner of paper products, as well as for reproductions of drawings in ever larger editions (virtually limitless when compared to those of engraving, etching, or woodcut). At the same time, Napoleon and his armies, who had been introduced to the technique during their occupation of Germany (Napoleon even visited Senefelder's shop in Munich in 1806), used lithography to manufacture maps and propagandistic images; newspaper editors and book publishers used it to introduce caricatures and illustration into the popular press, and music publishers fulfilled Senefelder's early intention by using it to reproduce musical scores, now with the addition of vignettes, frontispieces, and other forms of illustration.

Within forty years, lithography was the technique of choice for both the "modern" information revolution (advertising, the popular press, instruction manuals) of Europe's burgeoning commercial culture and, in the fine arts, for romanticism's revival of medievalizing imagery and stylistic effects, as well as realism's and later, impressionism's, dedication to the modern here-and-now of urban and suburban life. The medium's relative ease of execution, subtle transfer of artistic effects, and sturdy reproducibility made it the print technique of the nineteenth century, just as in the twentieth century, during the 1960s, with all of its sunny optimism, commercial expansion, and social unrest, it was the print technique that fueled the so-called American print renaissance. It was exactly lithography's adaptability that made it a viable option to artists who disliked, or did not want to learn, traditional print techniques, but who were willing to extend their usual drawing and painting into a printmaking procedure. This adaptability, or accessibility, is the theme of the exhibition.

Many exhibitions have celebrated the art of lithography, and many no doubt are still to come. But none have been as sharply focused on the unique qualities of the printing technique as *Touchstone: 200 Years of Artists' Lithographs.* In her two essays, Marjorie B. Cohn, the Fogg Art Museum's Carl A. Weyerhaeuser Curator of Prints and organizer of the exhibition, explores different aspects of the "touch" of lithography and the technology of "transfer" lithography, the means by which artists worked around the reversal of the image inherent in printing. And in her essay, Clare Rogan, the Fogg's 1995–96 Lynn and Philip A. Straus Intern in the Print Department, examines the early history of artists dealing with the reproductive character and potential of the new technique. Together these studies make fundamental contributions to our understanding of the revolutionary qualities of lithography and its history of technological advancement and artistic and commercial application.

We are grateful to Marjorie Cohn and Clare Rogan for their scholarly work on this project, just as we are indebted for the generous support of the exhibition to our good friend Albert H. Gordon, who this year celebrated the seventy-fifth reunion of his graduating class from Harvard College. And to our lenders and our colleagues at the Ackland Museum of Art of the University of North Carolina at Chapel Hill, the Agnes Etherington Art Centre of Queen's University, Kingston, Ontario, and the University of Michigan Museum of Art, Ann Arbor, we extend our most sincere thanks.

James Cuno
Elizabeth and John Moors Cabot Director

Acknowledgments

The authors individually are most grateful to each other: it has been an enthusiastic and satisfying collaboration over several years. Together, we thank Anne Anninger for her initial suggestion of an exhibition that would have been a three-way collaboration had not scheduling conflicts interfered, and we also thank James Cuno for his support through thick and thin. We are also grateful to Philip and Lynn Straus, whose internship grant to the Print Department provided the framework for our collaboration.

A generous gift from Albert H. Gordon early in the long history of this project allowed us to work on our catalogue without the usual interruptions to write begging letters and byzantine grant applications; he is truly our angel.

Although the greatest part of our exhibition is drawn from the Harvard University Art Museums' collections, we have been very fortunate to secure a few essential loans from the Houghton Library and Fine Arts Library here at Harvard, from Philip and Lynn Straus, and from another private collector who prefers to remain unnamed. We are most grateful to them all.

Research assistance and good advice have been gratefully received from Clifford Ackley, Tawney Becker, Craigen Bowen, Gil Einstein, Mel Hunter, Ellsworth Kelly, Anne MacDougall, Timothy David Mayhew, Robert Mowry, Stephen C. Pinson, Elizabeth Prelinger, Nesta Spink, Emily Rauh Pulitzer, and Martha Tedeschi. David Becker, Kermit S. Champa, Martin Cohn, and Elizabeth Mitchell have offered valuable editorial advice. Porter Mansfield has labored endlessly over the minutia of the checklist and its bibliography.

These acknowledgments have been written prior to setting the wheels in motion for the exhibition and catalogue's realization. We look forward to working with our designer, Howard Gralla, and with Craigen Bowen, Maureen Donovan, Danielle Hanrahan, Evelyn Rosenthal, and their staff. Past experience guarantees a productive, jolly joint enterprise.

Marjorie B. Cohn and Clare I. Rogan

Introduction

Marjorie B. Cohn

Throughout lithography's two-hundred-year history, its advocates have split along a great divide, or perhaps a fault line: on one side are those who value the touch of the artist as expressed in lithographs, and on the other, those who lay a greater emphasis on the realization of visual qualities and technical capacities unique to print-making generally and to lithography in particular. Admittedly, this is a parochial distinction, made within only a minor province of a larger realm. Because it is a printing method, lithography's reach is far greater than that of painting or drawing or any other fine art manifestation. Since the invention in 1798 of what was then called chemical printing from stone,[1] this reproductive technique has developed in every imaginable direction. Commercially it has been adapted to produce everything from microchip wafers to barn-sized posters. Lithographs can be made from photographs, and now from digitized images and computerized instructions compiled as bitmaps. Yet it has also remained a premier fine-art print process.[2]

Walter Benjamin saw lithography as merely the last way station on the road to photography, the chemical printing invention of the next generation:

... only a few decades after its invention, lithography was surpassed by photography. For the first time in the process of pictorial reproduction, photography freed the hand of the most important artistic functions which henceforth devolved only upon the eye looking into a lens.[3]

But Benjamin was concerned here for the description of form, not for its expression. Even the earliest promoters of photography had characterized it as an image-making process that required no "knowledge of drawing" or "manual dexterity,"[4] implicitly recognizing that photography's reproduction of the appearances of the world is the exact opposite of the unique capacity of lithography: the graphic replication of the tactile presence of the artist.

Any appreciation of this capacity contends with staunch defenders of lithography as preeminently a printing process. Their terrain has been staked out most recently and succinctly by Pat Gilmour and Antony Griffiths, two of the most intelligent contemporary interpreters of prints:

[I]t is not difficult to argue that this cyclical return to an aesthetic more appropriate to painting may have hindered the formulation of a true aesthetic of the print. The best reason for making graphic art is to do something that cannot be done in any other way. And the truth is that the potential the print has for multiplication is acquired at the expense of direct touch.[5]

The truth, of course, is that lithography only becomes interesting as an artistic medium when it produces something different from drawing.[6]

For the purposes of argument, however, we come down on the other side. In this exhibition we join those who have denied to lithography any special qualities except its extraordinary capacity to liberate the draftsman or painter from the contingencies of printmaking process and effect, those who have seen it as most original and authentic when it is most reproductive. Here is William Ivins, bundling his characterization of lithography into an article on early German woodcuts:

[Lithography is] a graphic process that cleanly separated the art of draughtsmanship and the craft of making printing surfaces ... which permitted the great draughtsman to make original prints in his accustomed mode of drawing without requiring him to alter either his manual practice or his habit of thought, or to distract his creative capacity through having to master a new technique of craftsmanship.[7]

Unlike previous printmaking techniques, lithography allows the artist to use his or her accustomed tools: pen, brush, and crayon (and, in transfer lithography, paper). There is no need to adapt the pressure of the hand and the movement of the arm to carving, or to translate in the mind's eye the visual sensation of coppery lines gleaming on a dark ground into the effects of black ink on white paper. The lithographer retains all of the expressive range of traditional drawing media, and attractive options such as scratching and blotting, and even direct bodily contact, can be substituted for more academic procedures.

Lithography has traditionally separated the actual production of prints on paper from the creation of their image on the printing matrix, with commercial shops taking the artist's drawing on stone, plate, or paper and processing it through numerous chemical and mechanical stages, procedures that far outstrip relief and intaglio printing in technical complexity and requirements for capital investment. Historically, woodcut, engraving, and etching were also conventionally commercial enterprises, which likewise segregated the functions of designer, plate or block maker, printer, and publisher, but there was a parallel tradition in these techniques of printmakers who created their impressions from start to finish.

With only a few notable exceptions, this has not been the case among artists who have made lithographs. They have drawn them, but they have not printed them. Although inhibited from printing, they were liberated to pursue creative options that might have been foreclosed by involvement in a continuous graphic production process. As an expert lithographic printer observed, "An artist attempting to print his own lithographs not only finds his work in other media suffering ... but his lithography suffers as well, because he finds himself limiting his techniques to what only he can print."[8]

Inevitably, process leaves its marks on the product. There are many lithographs where the collaboration of printers has made production crucial to creation. This holds true especially for the elaborate color prints by Toulouse-Lautrec and his contemporaries, which have represented the peak of lithographic accomplishment to the general public. Yet while these are what one might think of as lithography's "major statements," they do not particularly express the direct contact of the artist's hand, unmediated by specialized techniques or printer's processes. In this exhibition, which virtually excludes color lithography, we look beyond the final surface of the lithograph to the first touch.

The contrast afforded by two Toulouse-Lautrec lithographs from his portfolio *Elles* is illuminating. In one, *Woman in Bed: Profile* (no. 88), the artist has used the resources of multiple stones to print several colors, a technique dependent on the collaboration of his expert printer. To complement the patterning inherent in the superposition of layers, in some areas Toulouse-Lautrec laid out his forms in broad planes, and in others he disciplined his strokes into repetitive patterns. In *Woman with a Tray* (no. 87), his monochromatic lithograph of the same subject, a prostitute in bed and her madam, he employed a wiry, accented, descriptive line as the sole expressive component. Perhaps it was the very similarity

of subject that tempted him to contrast what draftsmanly line alone could accomplish, without the technical wizardry of color. Toulouse-Lautrec's choice modulated his drawing style, and we seem to be closer here to his hand, unmediated by complex processing.[9]

A printer once wrote that "perfectly printed lithographs constitute the only absolutely autographic reproduction of a fine drawing which we have,"[10] unconsciously echoing the first English name for lithography: "polyautography." Setting aside the question of what constitutes "perfectly printed," this exhibition celebrates the "autographic": the capacity of the process to convey exactly and immediately the artist's marks, made usually with crayon or pen, in some cases with the fingertips, in one example with the touch of her lips.

I EXPLORE the implications and consequences of this approach to lithography in my first essay, "The Artist's Touch." Although there was a definite ebb and flow in the history of disagreement about the validity for lithography of, for example, the sketch style of drawing, I do not consider the topic chronologically. Instead, in this essay and also in my consideration of transfer lithography, I discuss the actual manifestations of touch and transfer as methods of making marks with special potential in lithography, and their implications within the creative process.

It seems useful, however, to operate within a chronological framework in investigating lithography's initial impact on draftsmen and painters. In "Drawing Lithography: Originality and the Graphic Sign in France and England, 1798–1830," Clare Rogan examines the first attempts to deal with this new opportunity for replicating freehand drawing and multiplying the effects of paintings. The various approaches and solutions found in this early spurt of creative engagement by Géricault, Goya, and Delacroix provided some of lithography's most compelling images and set precedents that would shape its evolution through the next century. Rogan also considers how lithographic representations of drawings were used for the teaching of drawing, which was rapidly becoming democratized through the production of manuals for provincial artists and amateurs, and she signals contingent associations of the new technique with political positions at the beginning of the nineteenth century.

My second essay, "The 'Freedom and Extravagance' of Transfer Lithography,"[11] treats issues that were of

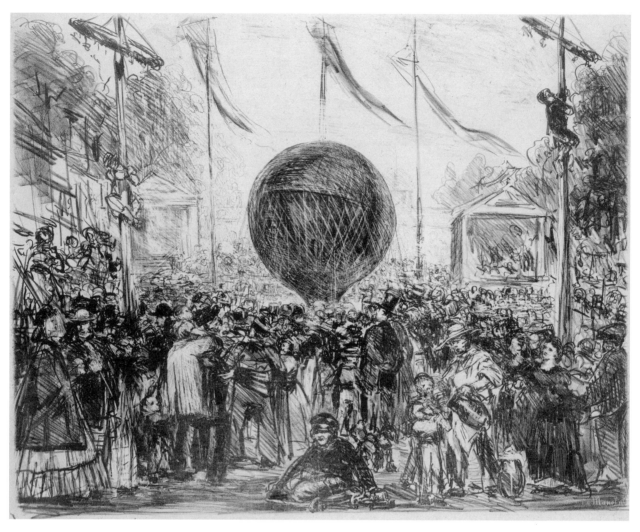

Fig. 11 Manet, *The Balloon*, no. 55

Doré for his edition of *La legende du juif errant* (no. 22, fig. 2). Ironically, this vivid evocation of the artist's touch advertised reproductive woodblock illustrations engraved by others. Doubtless the freedom of its drawn style was not an issue with Lemercier because of the commercial function of the lithograph as an advertising poster, a lower order of print initially despised by artistic lithograph lovers as "that skin disease of poorly maintained municipalities."[31] (Note that the Doré poster was authorized for indoor installation only.)

To return to the parallel with etching, by the end of the nineteenth century, when artistic lithography had gained more than a toehold, critics and artists regretted that its resources had not been available to the old masters, especially Rembrandt, whose etchings were for them the epitome of free graphic expression. A friend of

Degas remembers that "'If Rembrandt had known about lithography,' he [Degas] was fond of saying, 'heaven alone knows what he might have made of it.'"[32] "The most delicious Rembrandt etching" was compared to "the least sketch of Charlet on stone," and it was "the latter that betrayed its author's intentions the less."[33]

Always in this context it is the identity of lithography with drawing that is its special virtue. One of the more peculiar confusions on the part of an appreciative critic is found in a review of an exhibition of Whistler lithographs. He actually turned the lithographs on view into drawings in the context of stressing the artist's truth to materials: "It is not easy to analyse their charm, but it consists in large part of the nicest feeling for a pencil stroke and its peculiar qualities.... Mr. Whistler ... knows exactly what can be expressed with oil, water-colour,

greatest concern to artists, publishers, and collectors at the end of the nineteenth century, even rising to such a contentious level that a slander suit was brought, and won in court, by an artist against a newspaper reviewer who had implied that his transfer lithographs were not "real" lithographs. To some extent, these arguments about the validity of transfer lithography abated through the course of the twentieth century, but only, perhaps, because new technical developments raised even more horrifying prospects to defenders of the integrity of stone lithography.

Inevitably, any analysis of the arguments about the status of the transfer lithograph leads to contemporary Mylar-process and offset lithographs, and their "compromises" with originality. All of these issues in the end come back to lithography's unique capacity to reproduce perfectly the marks and surfaces of other media, and to the ultimate questions about reproduction and originality that lurk below the surface of all discussions of printmaking. In today's world of mechanical, photographic, and electronic simulations of reality, a world that values the unique work of art so highly, do we place great value on the perfect reproductive medium of lithography precisely because it reproduces the artist's original touch?

1. The basic principle of lithography is the mutual repulsion of water and grease. The design is drawn in a greasy substance directly onto a substrate that also accepts water, or else it is transferred onto such a substrate, which will be the printing matrix. This matrix, traditionally a limestone slab and now often a zinc or other metal plate, is then chemically processed to fix the design so that it will not smear or weaken, and to render the surface of the matrix not covered by the design more hydrophilic. Thus prepared for printing, the matrix is coated with water and then ink for each passage through the press. The moisture on the undrawn-upon areas of the matrix prevents the greasy printing ink from adhering to anything except the design.

2. See Mel Hunter, "What Is and Is Not a Lithograph," *Print Thoughts* 1, no. 2 (1995): 2.

3. Walter Benjamin, "The Work of Art in the Age of Mechanical Reproduction," in *Illuminations*, trans. Harry Zohn, ed. Hannah Arendt (New York, 1969): 219.

4. I am indebted to Stephen C. Pinson for this specific reference and more generally for his provocative thoughts on the development of transfer lithography as a reproductive medium. See Stephen C. Pinson, "Reproducing Delacroix," *Visual Resources* 14, no. 2 (1998): 151–83. The above description of daguerreotypy was offered to the French Chamber of Deputies by François-Dominique Arago and Joseph Gay-Lussac in the summer of 1839.

5. Pat Gilmour, "Kenneth Tyler, A Collaborator in Context," in Elizabeth Armstrong, Pat Gilmour, and Kenneth E. Tyler, *Tyler Graphics: Catalogue Raisonné, 1974–1985* (Minneapolis/New York, 1987), 9–10. The reader is recommended to a volume edited by Pat Gilmour, *Lasting Impressions: Lithography as Art* (London, 1988), which contains excellent and varied essays presenting lithography from the alternate perspective, that of the collaboration of artist and printer.

6. Antony Griffiths, "Reflections on the History of Lithography," *Grapheion* 1 (1997), n.p. Other eminent contemporary writers on lithography have weighed in with similar statements; see, for example, Walter Koschatzky, "Zur Geschichte der Lithographie," in Walter Koschatzky and Kristian Sotriffer, *Die Kunst vom Stein* (Vienna/Munich, 1985), 11–12.

7. William Ivins, "An Exhibition of German Prints of the XV and XVI Centuries," *Bulletin of the Metropolitan Museum of Art* 29, no. 5 (1934): 78.

8. Burr G. Miller, of George C. Miller & Son, Inc., quoted in Michael Knigin and Murray Zimiles, *The Contemporary Lithographic Workshop around the World* (New York, 1974), 125. Also see Riva Castleman, *Technics and Creativity: Gemini GEL*, exh. cat., Museum of Modern Art (New York, 1971), 8–10, for a provocative discussion of the inherent conflict between the identicalness of lithographic prints and the desire for variation among impressions fostered both by the other traditional graphic processes and by the developing notion of the artist as an expressive individual.

9. A first state of *Woman in Bed: Profile*, in which only the monochromatic basis for the composition has been completed, shows how dramatically the style as well as the substance of the image was altered by the addition of color. See reproductions of the first and published states in Wolfgang Wittrock, *Toulouse-Lautrec: The Complete Prints*, 2 vols. (London, 1985), 1: 395.

10. Bolton Brown, "Lithographic Drawing as Distinguished from Lithographic Printing," *Print Connoisseur* 2, no. 2 (1921): 144.

11. The phrase "freedom and extravagance" characterizes transfer lithography in Sir Hubert von Herkomer, *A Certain Phase of Lithography* (London, 1910), 11.

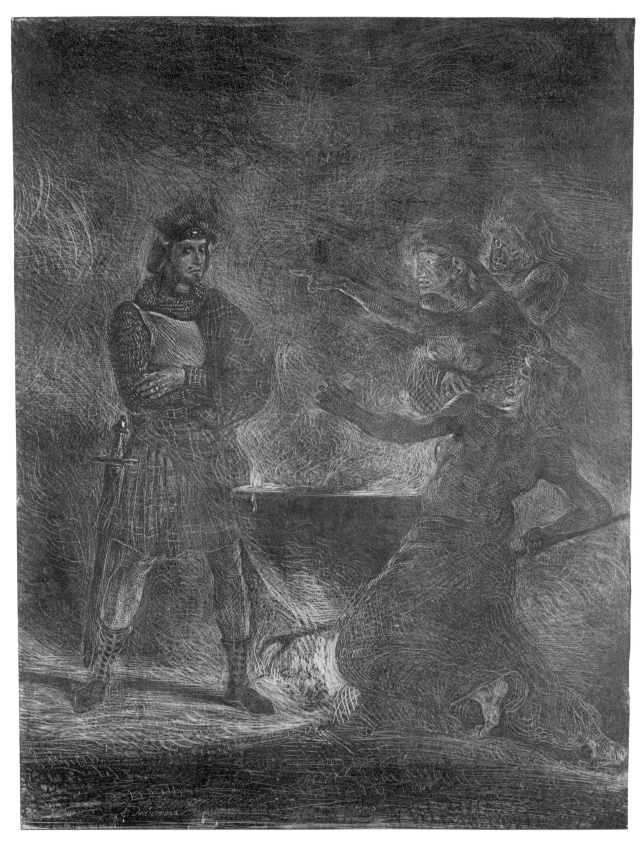

Fig. 1 Delacroix, *Macbeth and the Witches,* no. 16

The Artist's Touch

Marjorie B. Cohn

Perceiving a lack of trained lithograph printers in the United States, in 1959 June Wayne sought support from the Ford Foundation to establish a lithographic studio as an educational, as well as artistic, resource. Her characterization of the medium, whose very survival as an art form she felt was under threat, was peculiarly consonant with the reigning ethos of American abstract expressionism: "... the stone's unique sensitivity reveals the artist's hand in an expressive intimacy unlike any other print medium."[1]

Note that she did not restrict lithography to simple draftsmanship. While some of lithography's advocates, early and late, have stressed its special relationship to drawing,[2] others have recognized that it could receive marks more akin to painted strokes and tones—indeed, that it could mediate among the media, making it the "playground of individuality.... Lithography liberated painters and put them at risk"—gave them "Freiheit und Vogelfreiheit."[3]

Francisco Goya was indifferent to the risk in his four *Bulls of Bordeaux* (nos. 37–40), even ignorant of it, considering how early his works occurred in the evolution of the lithographic tradition. An eyewitness account describes how he "worked at his lithographs on an easel, the stone placed like a canvas. He handled his crayons like brushes and never sharpened them. He remained standing, walking backwards and forwards every other minute to judge his effects."[4] Goya started by covering his stones with a medium tone, the visual equivalent of a painter's toned ground; he then worked his designs up to light by scraping, and laid in dark accents with crayon in a sequence determined by the evolution of the compositions, without formula. His process anticipated the enthusiastic instructions given to a younger artist by that other great early-nineteenth-century painter-lithographer, Eugène Delacroix:

When you have drawn and even blackened your stone, rub it down with flannel, then redraw and reblacken it till you have modeled it according to your imagination. Then, with a scraper, take out more or less of the black, being careful not to go below

the grain of the stone.... When you have scraped and put in the lights, then you can lay in black again, stumping it till you have rendered your conception. Take a few chances and you'll discover all this sorcery for yourself.[5]

This process is reflected in Delacroix's *Macbeth and the Witches* (no. 16, fig. 1), dating, perhaps not coincidentally, from the same year as Goya's *Bulls*. Although superficially Delacroix's print appears less complex, with the design worked up with the point of a scraper from a dark background, in fact there are swirls of crayon strokes as a counterpoint to the white lines, and the background modulates suavely according to the intended effect: Macbeth's rings, hat jewel, and sword sparkle from intensely black shadows, while the supernatural witches are more vaporously modeled over gray.

The "sorcery" of work on the stone with reductive methods continued to inspire painters. Although sheer draftsmanship with crayon and ink is more apparent in lithographs by Manet and Doré on exhibition (no. 55, fig. 11; no. 22, fig. 2), close examination also reveals their liberal use of scraping for reduction of darks and definition of bright textures and accents. At the end of the nineteenth century Sir Hubert von Herkomer, in the erroneous belief that lithography had till his time "been kept strictly in the autographic groove," and feeling that a "graphic art that could only make a reproduction of a drawing in chalk, which so resembled the touch of the artist that it might be mistaken for the original, was, to my mind, no graphic art at all,"[6] developed Goya's and Delacroix's dark-to-light system all over again—as would Robert Riggs in the 1930s (no. 80).

Of course, Herkomer did not want his prints to look any less "autographic" in the sense of being authentic products of his hand; what concerned him was developing his print past the simple sketch stage, to incorporate the painterly values of a full range of tone and modeling in means peculiar to lithography. In fact, this had been the concern of some advocates for lithography from its invention. Its resources along this line were developed through two other means aside from the combination of

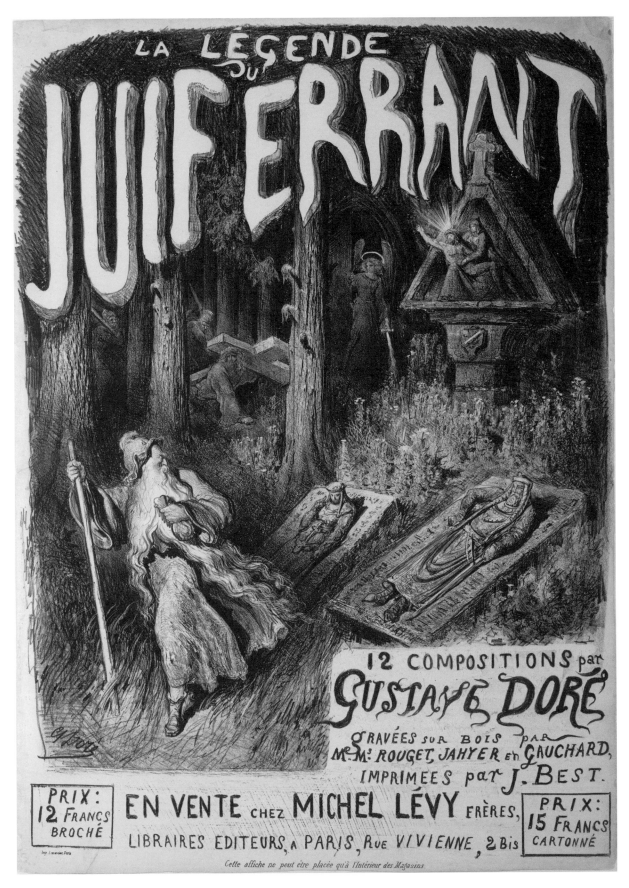

Fig. 2 Doré, *Poster for "La Legende du juif errant,"* no. 22

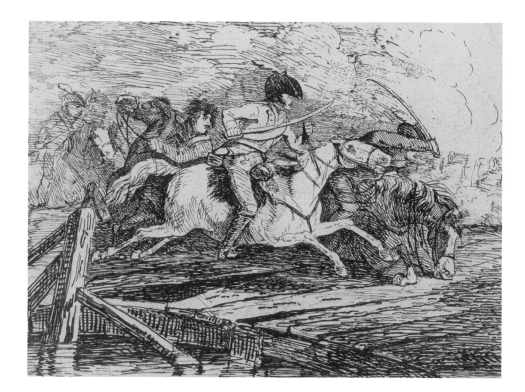

Fig. 3
Gessner, *Cavalry Charge,*
no. 36

positive and negative development of form embodied in the prints cited above.

The very first lithographs, such as those by Gessner and Stothard in this exhibition (no. 36, figs. 3, 18; no. 85), were drawn in ink, not crayon, and technicians gradually evolved means to dilute the liquid into washes that would print in all the shades of translucent gray available to the artist in watercolor painting. Whistler's *Early Morning* (no. 92) is among the earliest lithographs to realize the full painterly capacity of lithographic wash, which is known as tusche. *Early Morning* is on view here in a rare first state, prior to Whistler's reworking the stone by reduction to lighten the veils of gray still further. The effect was so novel in fact that Whistler's lithotints, as this sort of lithograph is called, were described as photo-reproductions in a contemporary exhibition catalogue. A modern scholar has astutely surmised that Whistler's intention may have been to simulate the liquid translucencies of his contemporary oil paintings, which had become notorious in 1878 through the derisive criticism of John Ruskin.[7]

By the mid-twentieth century, the resources of tusche were fully developed and accessible to American abstract expressionist artists, who might have been expected to appreciate a printmaking technique that could exactly replicate their gestures in their accustomed medium, paint. Some, however, were alienated from lithography by its public associations, developed in the 1920s and '30s, with political action and social uplift. "I can't even think about it," said Franz Kline; "I'm involved in the private image."[8]

Others were disconcerted by the necessity of working with a printer, especially if the collaborative experience was complicated by the displacements and deferred satisfactions of color printing from multiple stones. In the words of a would-be collaborator, the master printer Kenneth Tyler, "Except for a few, like Motherwell, these Abstract Expressionists found it too frustrating to try to see a multicolored reality one layer at a time. They had to see all the color at once or they could not 'see' it at all."[9] Despite Tyler's exemption, Motherwell himself said that "large or colorful prints involving many matrices ... or solutions dependent upon other people [made] him feel like a foreign poet, the translation of whose work 'betrays the original text because the translator necessarily has a totally different sensibility, background and sense of nuance.'"[10] Although his color prints (in many different techniques) are fully realized compositions, the abstract expressionist aesthetic of spontaneous gesture is best recognized in the strokes and sprays of a single layer of printing ink, replicating his original brushload of lithographic tusche (no. 61). James Kelly resolved the issue of color in his *Red Wednesday* (no. 51, front cover) simply by choosing one, the most brilliant

Fig. 4 Kadish, *Untitled,* no. 48

red, and integrating it through printing with his gesture over the single stone.

The Motherwell and Kelly prints record abstract expressionist artists discovering the print medium that could accommodate a developed painting technique. But the chameleon-like adaptability of lithography could also contribute to a painter's overhaul of his method. Ted Wahl described an incident when Jackson Pollock discovered Wahl using an airbrush to apply tusche: "... he said, 'Hey, I want to do one.' And I said, okay. Then I got him a stone...."[11] Pollock had already drawn crayon lithographs in a regionalist style, but when he applied this new tool to lithography, it led him toward effects that he realized only later in paint. The airbrush was also used by James Rosenquist in *Zone* (no. 82); Rosenquist took with him that tool of billboard painting, his initial trade, to his 'high-art' painting, and found it easily adaptable to lithography as well.

The ease with which Pollock changed his lithographic practice to accommodate shifting style and artistic intention is embodied in this exhibition in two prints by Pollock's good friend, Reuben Kadish.[12] The earlier lithograph by Kadish blends surrealism and Mexican monumental style (no. 48, fig. 4), perhaps not an unexpected combination from an aspiring mural artist in the late 1930s. Conforming to both influences, lines are carefully drawn, and continuous tones model forms. By 1961, when Kadish went to the Tamarind Lithography Workshop as one of its first artists-in-residence, he had assimilated his friend's achievement, and his Tamarind lithograph (no. 49, fig. 5) exhibits a Pollock-like, painterly tangle of lines and forms to develop an equivocal space hovering at the picture plane.[13]

Lithography alone among printmaking techniques is sufficiently adaptable to such a radical metamorphosis by an artist who so completely transformed his touch

Fig. 5 Kadish, *Untitled,* no. 49

and who moved from the mode of a draftsman to that of a painter.

To return to the Motherwell on exhibition: its painterly effect is augmented by the colored paper on which it was printed, which removes it from the graphic black-on-white convention. This expedient was also used by the color-field painter Helen Frankenthaler in her *Bronze Smoke* (no. 30), where the exquisite adjustment of paper and tusche—the transparency of the tusche as well as the colors in which it and the underlying tone stone were printed—is suggested by the difficulty that her cataloguer found in describing the paper's color: "red-brown-pink."[14]

Both *Bronze Smoke* and *Red Wednesday* display yet another feature, purely characteristic of lithography, which distances the print more from drawing than from painting because it isolates the image from the paperiness of the artifact: the impress of the stone's edges, which sets off the image from the paper's edges and makes explicit that it is *not* a drawing on paper. The stone mark announces the technique and authenticates it as lithography and nothing else—a primary concern to the abstract expressionists, whose reservations about printmaking included its lack of authenticity in their terms, as the unique record of a creative moment. The explicit stone mark insured that, even if the creative moment were displaced by a generation because of the image's passage through the printing process after its making, and even if the print existed in more than a single example (with the implications of commercial interest inherent in a multiple), it would be clearly seen to be what it truly was—a lithograph.

Such extreme insistence on truth to materials arose first around 1907–8, among some members of the German movement Die Brücke, who in their quest for integrity of medium and expression, even when they attempted color lithographs, insisted on creating them from start to finish without the expedient of transfer paper or the assistance of printer collaborators. As can be seen in Ernst Ludwig Kirchner's *Dancer Seeking Applause* (no. 52), an archetypical German expressionist print, the stone mark reads in black, red, and blue. In this case the same stone was used three times, the artist printing all of the impressions in one color before launching into the next; he was too poor to afford more than one stone.[15]

In the case of the David Smith lithograph on view (no. 84), careful examination reveals that two stones of different sizes, each printed to their edges, were used for the two colors.[16] The blue stone provides a washy

tusche "sky" behind the black forms, which were vigorously drawn in crayon by the sculptor, with occasional accents in opaque tusche to fill the crayon's distinctive texture. Just as painterly equivalents can be identified in the lithographs of painters, Smith exploited a particular characteristic of the lithographic crayon as an equivalent to his sculptural process. The crayon was greasy but cohesive, and when the point was firmly pressed on the stone and then abruptly lifted, it picked up cleanly, causing a white fleck to appear in the image. The repeated white accents in the printed black forms analogize the highlights and thus evoke the textures of his wrought-iron pieces.

Yet another means by which lithographers approached the effects of painters, as opposed to draftsmen, was by the cumulative buildup of tone through repeated strokes. This was, of course, also the method of the traditional reproductive engraver, but the grained stone offered a different option to the lithographer. Whereas the plate-maker created his grays through a constructed linear array of hatching and cross-hatching, black on white, the lithographer could depend upon the grain of the stone to break up the surface that he shaded over with his crayons; the density of tone would depend simply on how deeply he filled its pores.

In fact, at the beginning of lithography, this method of building tone merely replicated a technique systematized in earlier French drawing practice. In his 1755 drawing manual, Charles-Antoine Jombert specified three "manners of drawing" with chalk or crayon: "Manière d'ombrer en hachant"—hatching—replicated the linear syntax of the etcher and engraver; "Manière de dessiner en grainant"—graining—toned without filling in the grain of the paper (which prior to the invention of wove papers always had a perceptible surface texture); "Manière d'ombrer en estompant"—stumping—rubbed the pigment into the paper so that it filled the grain.[17] Graining was the primary technique, with the other two serving as accent or complement.

These academic modes of drawing, with graining dominant, as prescribed, can be appreciated in Achille Devéria's *Self-Portrait* of 1830 (no. 21, figs. 6, 28), as radical in sentiment and execution as it was conservative in system. Exactly the opposite paradox is seen in the *Old Man Wearing a Turban* by Engelmann (no. 26, figs. 7, 19), whose originality resides not in the ends of representation but in the means. In this reproductive lithograph, the linear basis for the ultimate graphic convention of engraving, the lozenge and dot, is optically simulated by quick squiggles impossible to the engraver but second

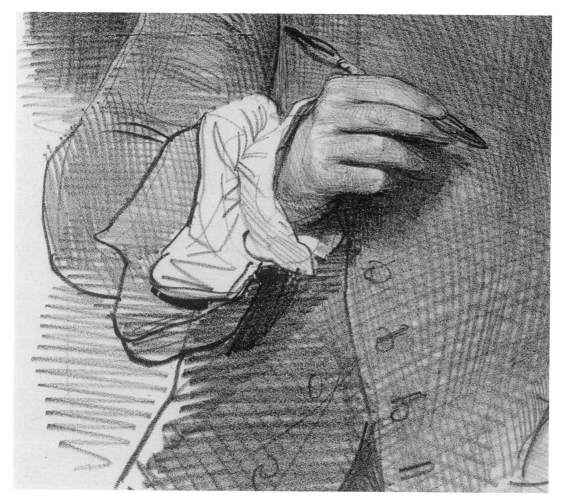

Fig. 6 Devéria, *Self-Portrait* (detail, actual size), no. 21

Fig. 7 Engelmann, *Old Man Wearing a Turban* (detail, actual size), no. 26

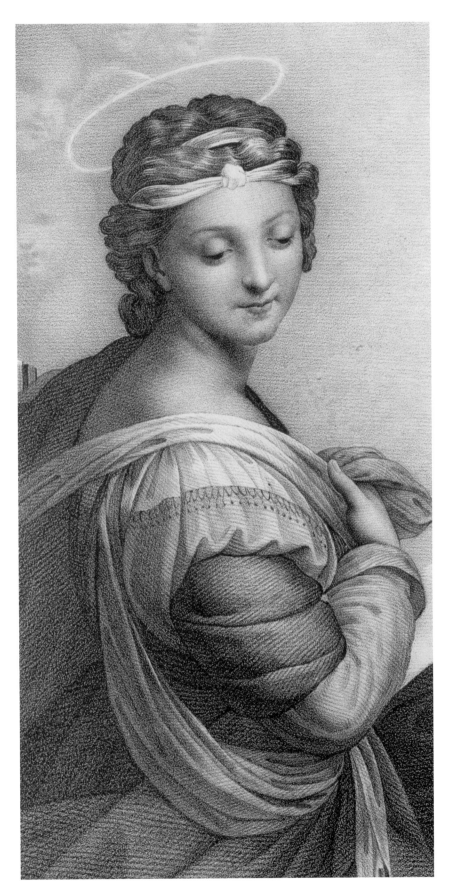

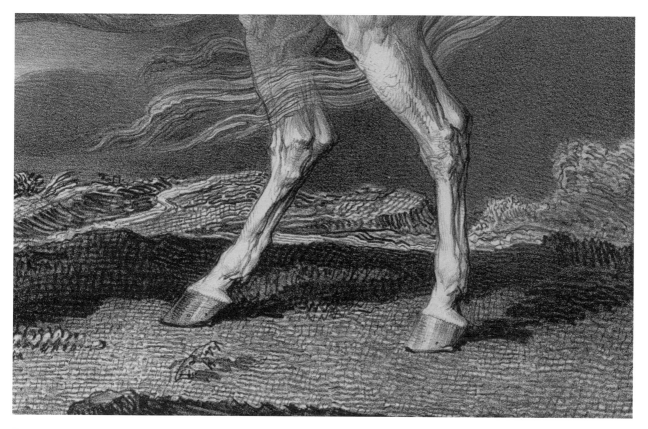

Fig. 9 Ward, *Adonis* (detail, actual size), no. 91

nature to the facile draftsman. Note how, in the lower right corner, the minute voids are loosely, serendipitously formed by the conjunction of adjacent zigs and zags of the pen. In traditional engraving technique these voids would be generated by the intersections of oblique hatching systems, forming a graphic net as rigid and orderly as the one that only the burin can make.

It might seem that a description of the modes of lithographic handling seen in the prints by Devéria and Engelmann should be deferred to the following discussion of lithography as drawing, but in the nineteenth century, except in academic practice, drawing as well as lithography would be overtaken by the sketch aesthetic. A reproductive lithograph such as Aubry-Lecomte's *Sistine Madonna* (no. 1, figs. 8, 29), which employs many of the hatching conventions of engraving, or an original image such as Delacroix's *Royal Tiger* (no. 19), shows all the compositional deliberation, tonal range, and finish of traditional painting. And an anecdote about Aubry-Lecomte suggests the cost of such nicety of shading: "He detailed the draperies of his great *Sistine Madonna* with such conscientious devotion ... that he contracted an untreatable cramp in his fingers. As a consequence,

he contented himself with reproducing the misty shadows and pearly reflections of Prud'hon."[18]

James Ward's *Adonis* should also be studied in this connection (no. 91, figs. 9, 27). While he imitated earlier eighteenth-century British print models—mezzotint in the overall effect of light emerging from dark and standard etched-line syntax in the landscape foreground—Ward was a master of the shading method peculiar to lithography, notable here especially in the sky. The author of the most authoritative British lithography manual of the time (perhaps not coincidentally published by the same house that issued Ward's *Adonis*) gave careful instruction in painterly shading practice:

The beauty of a tint, in order to print well, consists in it having a rich, soft and velvety look, although firm and solid at the same time. It is done not by working the chalk too quickly, but by producing the touch by a rather slow motion, as if painting with a brush.... If the chalk is moved too fast, particularly in the full tones, the heat produced by the friction softens the chalk, and from that cause gives to the tints a roughness and coarseness which is sure to be transmitted to the impression in an increased ration.

He went on to recommend "Mr. Ward's beautiful drawings on stone as perfect models to consult for the richness and fullness which he gives to all his tints."[19]

YET TO MOST of its advocates who recognized lithography's fidelity to the artist's touch, it was not its versatility of effect but rather its immediacy of response, the intimacy of its alliance of the hand with the imagination, that elevated it above any other print process. Lithographers who mastered graining were disparaged as *"lithographes"*—mere lithographers, compared to *"les peintres, qui font de la lithographie originale"* [painters, who make original lithographs]. As for mere lithographers, "[u]nencumbered with the concerns involved in composition or incapable of undertaking it, these practitioners bend all their efforts on the perfection of their craft. According to the lithographers, one knows nothing about lithography *if one does not grain.*"[20] Advocates for artist's lithographs asserted that the process should not attempt to compete with engraving or elaborate academic drawing because it could not, without being forced to abandon its "principal function: to translate directly a pictorial idea, to inscribe the stone at the very moment it has come to mind, with all the freshness of first inspiration, or even unfettered improvisation."[21]

Even if only those artists who had received the fullness of a painter's training could take advantage of this function, this projection of their lithographic capacities quite naturally suggests drawing more than painting, and indeed, it is drawing with which lithography at its most intrinsic is usually associated.

The epitome of lithography as drawing is seen in the enormous oeuvre of Honoré Daumier. As early as 1829, his first employer told him, "You have the touch."[22] Here "touch" conflates Daumier's rapier thrusts as a caricaturist and his legerdemain with the lithographic crayon, which would develop over the course of his long career so that by its conclusion he would be recognized as one of the greatest draftsmen of all time in any medium. It was William Ivins's appreciation of Daumier's lithographs as *drawings* that so mortified the printer Bolton Brown, who himself made exquisitely tonal lithographs:

Of one of his [Daumier's] unimportant things—a horribly bad print from a ruined stone—he [Ivins] said, "Do you see that? Well, there it is, the greatest lithograph ever made...." It was, he thought, a mere affectation to pretend to like a perfect impression better than any old rag, printed long after the design had become

but a barely visible wreck of itself.... He informed a friend of mine, as an evidence of my incapacity for the higher things of art, how I had "gloated" over "texture" and "quality."[23]

Of course, Daumier's line does read more clearly in rich impressions printed on clear white paper, as seen in the unpublished proof of *The Political One-Man Band* (no. 11). The published caricature *Citizen Auguste Thiers Trying On a New Outfit* (no. 10, fig. 10), which features the same cast of reprehensible characters, typifies Daumier impressions printed poorly, as they usually were in the satirical journal *Le Charivari:* on cheap paper with typeset text competing on the facing page and even with type striking through from the reverse of the lithograph. It vividly demonstrates how Daumier capitalized on a sketch style. His tremulous, repetitious, loopy lines are the antithesis of the rigid letter forms, and every subtle touch is amplified by the contrast.

Lithography was not, however, the first print process to be characterized as a simulacrum of drawing. Traditionally, it was etching that, in comparison with that other great genre of linear intaglio printmaking, engraving, faithfully conveyed the touch of the artist. Before the invention of lithography, the study of etchings was advocated to familiarize connoisseurs with a painter's hand.[24] At the very moment of lithography's first popularization, it was etching, executed "by the Master himself, [that was] associated with drawing, where the rapid flight of his thought is in some way fixed, and where the delicacy of expression is fully retained...."[25]

An artist such as Johann Christian Reinhart, fully trained in the eighteenth century in etching, would continue his habitual style when, in his middle age and in the youth of lithography, he hazarded the new technique (nos. 78, 79). Even after lithography was fully developed, in the mid-nineteenth century its rapid commercialization caused connoisseurs and collectors still to prefer etching, a more prestigious medium whose printing matrices sustained only limited editions, to convey artistic flights of thought. And so the international movement now recognized as the Etching Revival thrived in the 1850s and '60s, while lithography by artists languished.[26]

Curiously, one printmaker whose work was highly regarded by connoisseurs of etching in the 1850s, in 1873 took advantage of the capacity of the lithographic stone to accept any greasy mark and had the printer Lemercier transfer freshly struck impressions of his etchings to stones. We have on exhibition Rodolphe

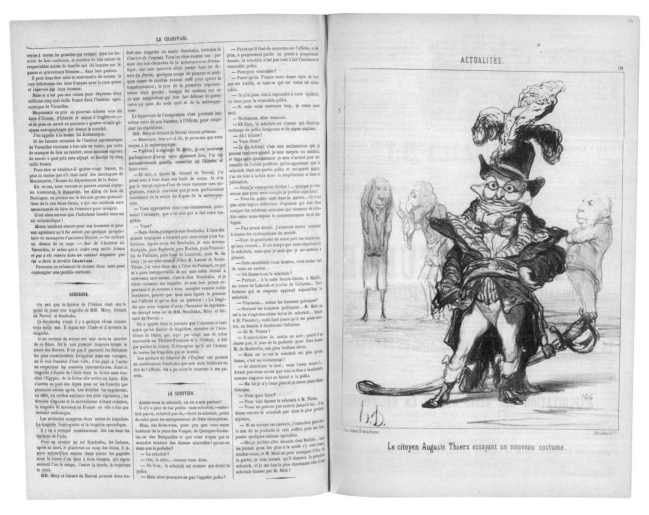

Fig. 10 Daumier, *Citizen Auguste Thiers Trying On a New Outfit* (double-page spread, as published in *Le Charivari*), no. 10

Bresdin's *Interior with Peasants from the Haute-Garonne* in both its etched and lithographed versions (nos. 3, 4).[27] The artist may have considered both techniques equivalent to drawing; this was certainly the case with lithography: his student Odilon Redon reported, "Decades later he could still recall how Bresdin 'insisted on calling lithographs *drawings on stone*.'"[28]

One wonders what the printer Lemercier thought of the decidedly eccentric Bresdin and his unique drawing style. By the 1870s the printer and his workmen may have resigned themselves to lithography's capacity to print any sort of mark on the stone, but only a few years earlier, when the publisher Cadart enlisted the leaders of the Etching Revival to produce a portfolio of lithographs, the project was thwarted by the horror at the printer's shop over the drawings on stone by Legros, Ribot, Fantin-Latour, Bracquemond, and—especially—

Edouard Manet: "at Lemercier's there was a shriek: it's horrid, mindless, wild, no one's ever seen such a thing, nobody would dare put such a thing on press!"[29]

As a result, Manet's first lithograph, *The Balloon*, survives in only five trial impressions on proofing paper (no. 55, fig. 11). Thirty years would pass before print connoisseurs, at the full tide of a lithographic revival, could value his work on stone—specifically its character as drawing—more than his etchings: "[His] hand manhandles stone even more feverishly than copper. It is a pleasure to see Manet manage the brush with the same ease as the Japanese in their sketches in black ink, and use ... the crayon, whose free, impetuous bursts flare like rockets...."[30]

In 1856, the same print shop where six years later the Manet would be rejected produced the remarkably freely (though more conventionally) drawn poster by

tone, pencil, or etching-needle.... There is hardly a drawing in this collection but what shows thought...."[34] But every "drawing" *was* a lithograph.

Of course, there were always those who continued to prefer intaglio prints to lithographs. Stanley William Hayter, determined to revive engraving, insisted, "But a lithograph, of course, is a drawing. The work does not get beyond it. Whereas engraving and etching go far beyond that—there are far more dimensions and greater transformation. So I think it's more interesting...."[35]

Even when an artist recognized that lithography involved more than the act of drawing, it still might seem less complex a printmaking medium than etching, because of the ease, the apparent superficiality, of making marks that print in lithography. So Brice Marden rejected crayon and wash on stone in favor of the more penetrating etching needle plowing through varnish: "Lithography," said Marden, "is like ice-skating. I'd rather walk through the mud."[36] Jasper Johns, skilled in both techniques, replied when asked to distinguish between them:

I'm not sure I know how to rank lithography and etching. I know that Aldo Crommelynck [a noted intaglio printer] thinks a lithograph is a kind of imitation drawing. I don't feel that. Lithography has very special qualities and is a genuine medium ... [but] It seems that etching can accept more kinds of marks than other print media can. In lithography one applies grease to the stone or plate, a greasy liquid or crayon; the result is a kind of wash effect or a crayon effect. That's about it.[37]

Against these negative opinions or qualified acceptance we can set the words and creations of lithography's advocates. Particularly telling is an anecdote from Kenneth Tyler, a would-be publisher of lithographs by Frank Stella. In order to be lured into printmaking, the artist required a medium exactly like that to which he was accustomed, which only lithography could provide: "One day he [Stella] said to me [Tyler] ... 'I draw with a magic marker—I wouldn't know what to do with a lithographic crayon.' So, I came back the next time with a magic marker filled with tusche. We seduced him!"[38]

Even more radical are the instances where the artist takes advantage of the capacity of the lithographic surface to reproduce any greasy mark, whether made by an artist's tool or not. Every early manual of lithography warned the novice of the susceptibility of the image to damage from bodily contaminants such as dandruff and fingerprints (no. 27). The very lack of fingerprints was, therefore, a testament to the skill of the lithographer (and printer). The conceptual artist Bruce Conner, who customarily never signed his works, was required by the Tamarind Workshop to sign his lithographs in order to certify that they were his artistic creation. When he insisted on signing with his fingerprints, an administrator at the press, which prided itself on its immaculate standards, was appalled. Conner then further mauled sensibilities by his "insistence that he be allowed to make a lithograph of that very same thumbprint on the largest plate he could locate at Tamarind," which, of course, he also signed with a thumbprint, to juxtapose two levels of reality.[39]

Other variations on the potential of the printed fingerprint were explored by Marisol and Tetsuya Noda. In Marisol's *Five Hands and One Finger* (no. 57), the artist applied both the palm and the back of her oiled hand to the stone, so that the printed image gives the curious and provocative impression of hands pressed against both sides of a transparent pane; the picture plane gains a whole new definition. Noda permitted his subject, his young son, to participate in the print by applying both his fingerprints and his scrawled line drawings, to provide a more autographic reality than his photo-lithographed image, which appears through a gray tone behind them as if at arm's length (no. 65, fig. 12).

The association of the fingerprint not only with the sense of touch but also as a unique and identifying personal characteristic was irresistible to such an egoist as Picasso.[40] Perhaps in his portrait of his son made up by the artist's rather than the subject's fingerprints (no. 73), he intended to attest to his creation of the child as well as the lithograph. The irony of the impress of the body as an actual record of the artist was taken further by Jasper Johns in his choice of draftsman's tracing paper to bear the trace of his anguished presence in *Skin with O'Hara Poem* (no. 47).

The power of the fingerprint to certify the artist's commitment to the image, carried in the Johns to the explicit extreme of grappling hands and face, is suggested almost subliminally in Miró's lithograph from his *Barcelona Suite* (no. 59, figs. 13, 35). The suite was made in the first years of World War II, which is its implicit subject. At the time, Miró had virtually ceased painting and was taking up sculpture and ceramics. He referred to "the need to mold with my hands—to pick up a ball of wet clay like a child and squeeze it,"[41] and modeling and realization of textures through rubbing is as important as drawing and painting in this set of lithographs.

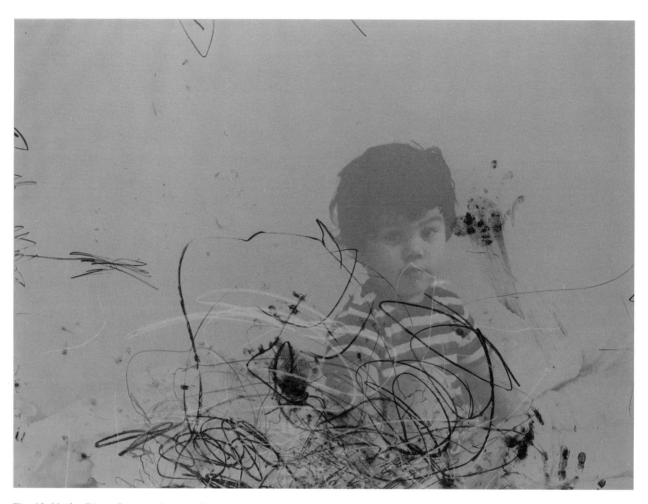

Fig. 12 Noda, *Diary: Sept. 1st, '74,* no. 65

Perhaps the vigorously jabbed finger marks on the head of the principal figure of *Plate XXIV* can be seen not only as dark accents applied for formal reasons, not only as signs of the artist's urge to model directly with his hands rather than at one remove with a tool, but also as an echo of the assaults of war. Brutality is even more directly suggested by the gashes visually reported in the textured surfaces of other areas, produced by rubbing lithographic crayon on transfer paper laid over gouged layers of *case-arti,* a premixed painter's ground which Miró acknowledged as a favorite material.[42]

In a more obvious association of the fingerprint with identity, and in a brilliant visual metaphor of the moral responsibility of individuals for the actions of their nations, Yukinori Yanagi clustered innumerable blue fingerprints into a curved teardrop shape to form one half of the *t'aegŭk,* the emblem at the center of the Korean national flag, symbolizing the complementary yin-yang opposites that comprise the whole of nature. The other

half of the *t'aegŭk* materializes from the superposition of the blue fingerprints over the *hinomaru,* the sun disc at the heart of the Japanese national flag; this he formed with innumerable red seal impressions (no. 95, fig. 14).

In *O Canada* (no. 94, fig. 15) Joyce Wieland exploited the sexual innuendo of the mark of a lipsticked kiss in a repeated mouth print, with each impress articulating a successive syllable of the national anthem. Surely the creases of the lips signify unique identity as exactly as fingerprints! While her print has been sedately charac-terized as an innovative documentation of performance art,[43] it stands on its own as a doubly loaded indepen-dent image. It is a feminist's acid satire against dominant macho patriotism, and at the same time it is an affec-tionate patriotic affirmation.

Wieland's lip prints are overtly erotic, but intimacy is subliminally suggested by any directly drawn lithograph in which one discerns the touch of the artist. The image may be utterly impersonal, yet the artist is vividly

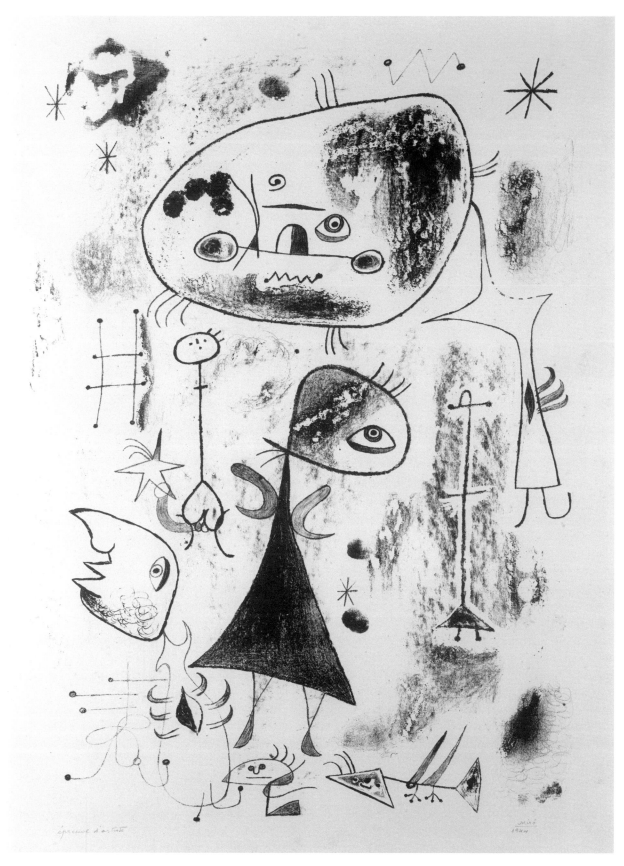

Fig. 13 Miró, *Plate XXIV*, no. 59

29/35

Fig. 14 Yanagi, *Untitled,* no. 95

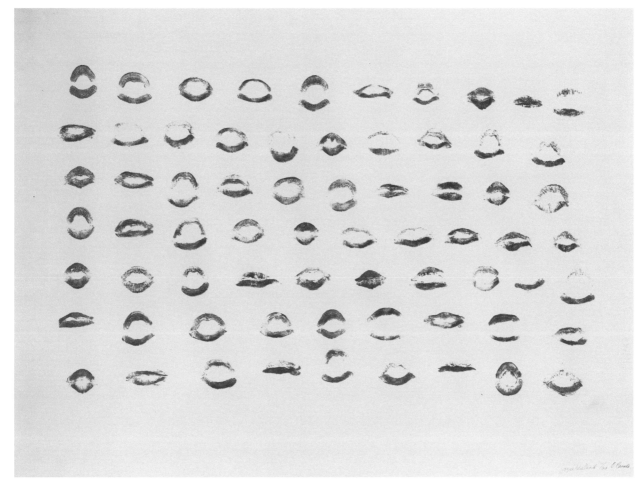

Fig. 15 Wieland, *O Canada,* no. 94

present, as in *Braque's Nail* (no. 68), where Oldenburg's virtuosic slackening of pressure on his crayon alerts us to the end of substance and beginning of shadow. He seems to have drawn it on the wall in front of our eyes. Lily Blatherwick has symbolized her presence and also her sense of the tactile quality of lithographic drawing, as well as succumbed to expedient practicality, by finger painting color onto her *Blown Poppies* (no. 2)—so much handier than printing impressions from multiple stones. In Grévedon's *Night (Sleep)* (no. 41, figs. 16, 17), our sense of touch is complicit with the artist's: he intended us to want to stroke the innocently proffered breasts, just as he stroked their swelling forms with his lithographic crayon. His loving touch tarried even more seductively over the billowing, trussed pillow.

The suggestive possibilities inherent in the directly drawn lithograph are so strong that some artists have consciously reacted against them. Here Richard Field queries the artist Richard Hamilton about his use of

photo-offset lithography, which eliminates the drawn and painted image, interposes a second layer as the printing matrix, and mechanizes the process as well:

R.F.: *"You've made it clear that you still hold a grudge against lithography. Is that because it requires the artist to use his hands?"*

R.H.: *"Yes, except for offset lithography. Offset is not so bad.... It's when lithography is at the craft level that perhaps it isn't so acceptable."*[44]

Robert Rauschenberg has adapted the capacity of the lithographic matrix to accept the mark of almost anything, with the simultaneity of printing eliminating any hierarchy of personal immediacy in its record. His *Visitation I* (no. 76) exhibits the direct touch of his brush almost as vividly as if the tusche had been washed onto the paper and not printed. At a further remove from reality are the strokes of his solvent-soaked tampon rubbing a newspaper clipping to transfer its ink to the

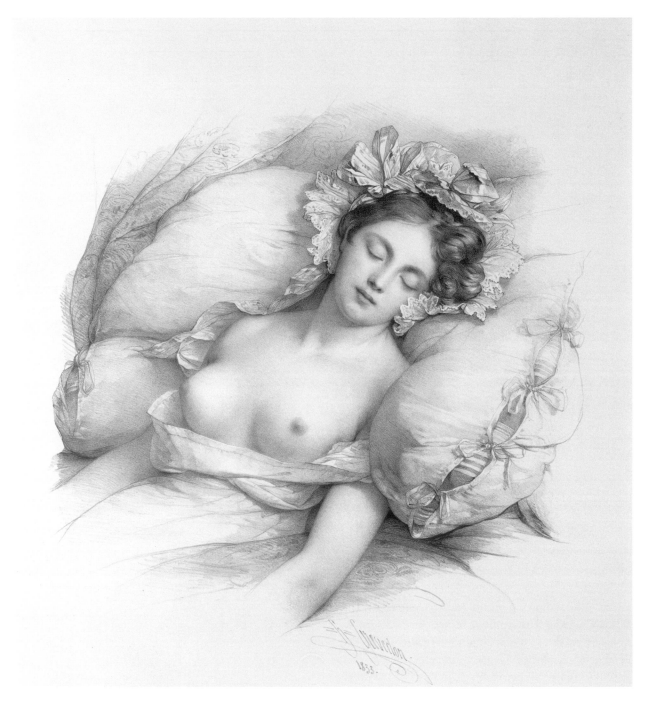

Fig. 16 Grévedon, *Night (Sleep)*, no. 41

printing matrix; still further is the halftone grid percep-
tible in the transferred photo-reproduction. Furthest is
the draftsman's quadrille paper pattern that lies behind
the superimposed black marks. The blue grid was
printed from a residual image found on the reverse of
one of the lithographic stones in the ULAE print studio
(which, like most contemporary lithographic workshops,

was forced to cull its stones from commercial sources
that had abandoned them in favor of plates and offset
processes). The flaws and splotches in the blue image
make clear that its appearance in this print is as much
an artistic choice as the application of tusche.

Rauschenberg has "savored the slight remove, the
odd formality, that the printed surface inserted between

Fig. 17 Grévedon, *Night (Sleep)* (detail, actual size), no. 41

the artist and the viewer. With the stone acting as an intermediary, the borrowed pictures and the artist's loose, painterly addenda coalesced into a pictorial mass in which the stolen and the invented were no longer separable."[45] In his own words, "They are an artistic recording of an action as realistic and poetic as a brush stroke."[46]

1. Quoted in Clinton Adams, *American Lithographers 1900–1960: The Artists and Their Printers* (Albuquerque, 1983), 199.

2. See Felix H. Man, "Lithography in England (1801–1810)," in Print Council of America, *Prints*, ed. Carl Zigrosser (New York, 1962), 104, where the author quotes from Johann Christian Hüttner's *Englische Miscellen* 13, no. 1 (1803). "The artist can have many thousand impressions of his drawing, and may justly call each impression his own work." A century and a half later, Miró was quoted as saying, "Lithography is more or less a new drawing technique...." (Joan Miró, *Joan Miró: Selected Writings and Interviews*, ed. Margit Rowell [Boston, 1986], 222). See the following essay by Rogan for a detailed analysis of the relationship of drawing and lithography in the early nineteenth century.

3. All translations are the author's, unless otherwise noted. Max J. Friedländer, *Die Lithographie* (Berlin, 1922), 10–11. See also the 145-word sentence by Kristian Sotriffer extolling all the transcen-

dental qualities of color and texture that lithographs can convey; he concludes rhetorically, "Oder ist es alles in einem?" ("Or is it all in one?") (Kristian Sotriffer, "Die Lithographie in der Hand—oder: Toulouse-Lautrec und die Folgen," in Walter Koschatzky and Kristian Sotriffer, *Die Kunst vom Stein* [Vienna/Munich, 1985], 36).

4. Antonio Brugada, quoted in Juliet Bareau Wilson, *Goya's Prints: The Tomás Harris Collection in the British Museum*, exh. cat., British Museum (London, 1981), 91.

5. Letter to Charles-Hippolyte Gaultron, quoted in Germain Hédiard, "Les lithographes de Delacroix," *L'Artiste* 2 (1889): 172.

6. Sir Hubert von Herkomer, *A Certain Phase of Lithography* (London, 1910), 3:2.

7. Martha Tedeschi, "Whistler and the English Print Market," *Print Quarterly* 14, no. 1 (1997): 31, 36. *Early Morning* is remarkably similar to the oil painting *Nocturne in Blue and Silver* (Fogg Art Museum, 1943.176), which appeared as evidence in the trial of Whistler's slander suit against Ruskin.

8. Quoted in Thomas B. Hess, "Prints: Where History, Style and Money Meet," *Art News* 70, no. 9 (1972): 29.

9. Quoted in Lanier Graham, *The Spontaneous Gesture: Prints and Books of the Abstract Expressionist Era*, exh. cat., Australian National Gallery (Canberra, 1987), 24.

10. Pat Gilmour, "Kenneth Tyler, A Collaborator in Context," in Elizabeth Armstong, Pat Gilmour, and Kenneth E. Tyler, *Tyler Graphics: Catalogue Raisonné, 1974–1985* (Minneapolis/New York, 1987), 24.

11. Quoted in Adams, *American Lithographers* (n. 1 above), 128.

12. Kadish introduced Pollock to intaglio printmaking at Hayter's Atelier 17, and it is thought that the skeinlike lines inherent in engraving, as well as the necessity to rotate the plate to make curves, was a significant influence on Pollock's continuing progress toward his unique painting practice.

13. Kadish assimilated another feature of Pollock's painting practice in this print: he rotated the stone in the process of developing his composition—and even after completing it. This impression, signed and inscribed by the artist along its (apparent) bottom edge, is rotated 180 degrees from the orientation indicated by the workshop stamp found upside down at its (apparent) top edge, and also by the print's reproduction in Tamarind Lithography Workshop, Inc., *Tamarind Lithography Workshop, Inc., Catalogue Raisonné, 1960–1970* (Albuquerque, 1989), no. 314.

14. Esther Sparks, *Universal Limited Art Editions: A History and Catalogue: The First Twenty-Five Years* (New York, 1989), n.p. [323], no. 32.

15. See Frances Carey and Antony Griffiths, *The Print in Germany 1880–1933: The Age of Expressionism*, exh. cat., British Museum (London, 1984), 31–35, for an excellent discussion of the lithographic technique of Kirchner and his associates in Die Brücke. Note, however, that other Die Brücke members did use transfer paper: the *Self-Portrait with a Pipe* by Nolde in this exhibition (no. 66) is a brush drawing on paper, which "reproduced" studies the artist had made of himself by lamplight. See Victor Carlson, "The Lithographs," in Clifford S. Ackley, Timothy O. Benson, and Victor Carlson, *Nolde: The Painter's Prints*, exh. cat., Museum of Fine Arts (Boston, 1995), 48–49, 154.

16. Adams, *American Lithographers* (n. 1 above), 185, tells the amusing story about Smith, who was almost as poor at the time as the German expressionists had been, and who tried printing his first lithograph himself, in a primitive studio in the countryside. An experienced printer who came to assist him found him printing with beer because there was no convenient water source. Although the print in this exhibition was done at the same place and time, it was not his first, and he presumably had the benefit of her more expert assistance.

17. Charles-Antoine Jombert, *Méthode pour apprendre le dessin* (Paris, 1755), 63–65. See the following essay by Rogan for further discussion of lithography's association with academic drawing practices.

18. Paris, Bibliothèque nationale de France, *Inventaire du fonds français après 1800*, ed. Jean Laran (Paris, 1930), 1: 212.

19. Charles Joseph Hullmandel, *The Art of Drawing on Stone* (London, 1824), 42–43. For a twentieth-century recommendation of the same technical approach, see Stow Wengenroth, *Making a Lithograph* (London/New York, 1936), 18–20.

20. Henri Beraldi, *Les graveurs du XIXe siècle* (Paris, 1886), 4:103, n. 1. See the essay by Rogan for an extended discussion of these issues as they arose during the first years of the nineteenth century.

21. Henri Delaborde, "La lithographie dans ses rapports avec la peinture," *Revue des deux mondes* 47, no. 3 (1863): 594.

22. Quoted in Howard P. Vincent, *Daumier and His World* (Evanston, 1968), 9.

23. Bolton Brown, "My Ten Years in Lithography," *Tamarind Papers* 5, no. 2 (1982): 41.

24. Jonathan Richardson, *The Works of Jonathan Richardson: "A new edition ... with the Addition of an Essay on the Knowledge of Prints, and Cautions to Collectors"* (London, 1792), 166–67.

25. F. L. Regnault-Delalande, writing in 1817, quoted in Timothy Clayton, *The English Print, 1688–1802* (New Haven/London, 1997), 302, n. 80. This follows by only a few years the publication by Adam Bartsch of the first volume of his *Le peintre graveur* (Vienna, 1803), which catalogued etchings, engravings, and woodcuts by the artists who had originated their compositions, with its impassioned preface advocating prints as a substitute for drawings: "Lightly traced or more finished, they survive for us in place of sketches and first conceptions.... We take special note of the skill and spirit peculiar and distinctive to them...."

26. For subtle analyses of the perception and role of etching at this period, see Timothy Allan Riggs, *L'Estampe Originale: A Late Nineteenth Century Publication of Original Prints* (M.A. thesis, Yale University, 1966), 5–13; and Douglas Druick and Peter Zegers, "Degas and the Printed Image," in Sue Welsh Reed and Barbara Stern Shapiro, *Edgar Degas: The Painter as Printmaker*, exh. cat., Museum of Fine Arts (Boston, 1984), xxiii-xxiv.

27. Note that the impression of Bresdin's etching in our exhibition is of a state that postdates the transfer lithograph. It has been suggested that Bresdin had the transfer made to take advantage of the lesser printing costs of lithography, compared to etching.

28. Quoted in Ted Gott, *The Enchanted Stone: The Graphic Worlds of Odilon Redon*, exh. cat., National Gallery of Victoria (Melbourne, 1990), 22. Gott also quotes a reviewer of an 1882 exhibition of Redon's lithographs who could only praise them in terms of etching: "Redon's lithographs are veritable etchings, presenting oppositions of light and darkness with accumulations of shadows that have never before been attempted on stone" (13).

29. Germain Hédiard, *Fantin-Latour: Catalogue de l'oeuvre lithographique du maître* (Paris, 1906), 16. Lemercier was not the first printer repelled by stones because of their radical freedom of expression; the same story is told of Delacroix's first independent lithographs, his studies after antique coins (Germain Hédiard, "Les maîtres de la lithographe: Paul Huet," *L'Artiste* 1, new period [1891]: 2).

30. Roger Marx, "Simples notes sur les peintres graveurs," *L'Artiste* 5, new period (1893): 287.

31. Beraldi, *Les graveurs* (n. 20 above), 169. The phrase—"l'affiche, cette maladie de peau des villes mal tenues"—occurs in a fascinating discussion of the difference between the "gravure" and the "estampe," that is, between high-class and low-class prints.

32. Ernest Rouart, quoted in Edgar Degas, *Degas by Himself: Drawings, Prints, Paintings, Writings*, ed. Richard Kendall (London, 1987), 305.

33. Henri Bouchot, *La Lithographie* (Paris, 1895), 13.

34. "Mr. Whistler's Lithographs," a newspaper review of the Fine Arts Society 1896 exhibition, London, from the Pickford Waller scrapbook copy of the exhibition catalogue in the Metropolitan Museum of Art. I am most grateful to Nesta Spink for this reference.

35. Quoted in Pat Gilmour, "Interview with Stanley William Hayter," *Print Review: Prints USA 1982* 15 (1982): 14.

36. Quoted in Susan Tallman, *The Contemporary Print* (London/New York, 1996), 100.

37. Quoted in Christian Geelhaar, *Jasper Johns Working Proofs*, exh. cat., Kunstmuseum Basel (Basel, 1979), 63–64.

38. Elizabeth Armstrong and Sheila McGuire, *First Impressions: Early Prints by Forty-Six Contemporary Artists*, exh. cat., Walker Art Center (Minneapolis and New York, 1989), 60.

39. Ibid., 54. Finally, when Conner was required to have his fingerprints on file with the Palo Alto police department in order to teach, he insisted that his prints had value, as authenticated by their issuance as fine art lithographs by Tamarind. A compromise with the regulation was reached when he was allowed to produce and sell an edition of twenty police fingerprint cards, each a sort of relief monoprint, with the attending officer as printer. See Peter Selz, "The Artist as Dactylographer," *Art in America* 62 (July–August 1974): 98–99.

40. Softground etching can also record the fingerprint, from the impress of its texture, which picks up the sticky ground from the plate. The contemporary sculptor Joel Shapiro produced (but did not publish) an etching comprised entirely by his repeated thumbprint in 1970, and Tàpies's *Suite Catalano, Plate 2* (1972) bears a footprint. Perhaps the most famous printed fingerprint is the one imposed by Thomas Bewick over a vignette of a pastoral landscape, presumably as an assertion of the artist's dominion. This, however, was engraved by Bewick into his boxwood block and was not a direct transfer from his digit (Thomas Bewick, *History of British Birds*, [Newcastle, 1797], vol. 1, *History and Description of Land Birds,* 175).

41. Miró, *Joan Miró* (n. 2 above), 208.

42. Ibid., 189, 192.

43. Mark Pascale, "Printmaking (on Everything), Apology to Terry Allen," in Joseph Ruzicka, *Landfall Press: Twenty-Five Years of Printmaking,* exh. cat., Milwaukee Art Museum (Milwaukee, 1996): 24–25.

44. Louise Sperling and Richard S. Field, *Offset Lithography,* exh. cat., Davison Art Center (Middletown, Conn., 1973), 24.

45. Tallman, *The Contemporary Print* (n. 36 above), 33–34.

46. Michael Knigin and Murray Zimiles, *The Contemporary Lithographic Workshop around the World* (New York, 1974), 31.

Drawing Lithography: Originality and the Graphic Sign in France and England, 1798–1830

Clare I. Rogan

"A lithographic impression is not even a facsimile of the work of an artist of eminence, but the original drawing itself."
—Charles Hullmandel, 1824[1]

Following the invention of lithography in 1798, both advocates and critics of the new printing method—which was neither an intaglio nor a relief process, and thus fell outside established classification systems—sought terms appropriate to the new technique. For the first thirty years, the predominant analogy was to drawing: as early as 1802, a lithographic print was described as "an impression of the drawing ... exactly resembling the original."[2] By comparing lithography to drawing, printers such as Charles Hullmandel and Godefroy Engelmann were calling on the associations of originality and genius attached to the sign[3] of drawing in the early nineteenth century. Yet by the 1820s, the very idea of the drawing was being redefined by romantic artists, and in France the debate over sketch aesthetics functioned as a proxy for political debate. The aesthetic and political associations of the signified, drawing, were in flux, and threatened to undermine the printers' intentions. Moreover, the analogy between the new medium and the originality of drawing contradicted the commercial strength of the technique: the almost limitless reproducibility of lithography. By calling on the associations of the drawing, British and French promoters hoped to give their new method the status of originality and fine art, but instead lithography rapidly evolved into a sign of cheap material suitable for the lower classes.

While other printing techniques were also occasionally promoted as forms of drawing, lithography, for purely technical reasons, is arguably closer to drawing than any other print technique. Invented in Bavaria in 1798 by Alois Senefelder, lithography differs fundamentally from the earlier established processes. Relief and intaglio printing are essentially mechanical processes based on visible distinctions in level in the surface of the matrix, usually a woodblock or copper plate. Unlike these methods, lithography is a planographic technique, printed from a flat (*plano-*) surface, most often a limestone block: the dispersal of the printer's ink is based on chemical, not mechanical principles.

Since a lithograph is printed directly from an image drawn in greasy ink or crayon on stone, unlike a relief or intaglio print, a lithograph is both an icon and an index of the drawn line. According to the semiotic schema of Charles Sanders Peirce, there are three classes of signs: the icon, the index, and the symbol. The icon is related to the object by similarity, the index by contiguity, and the symbol by convention alone.[4] The lithographic print is not only an icon, since it resembles the drawing, but it is also an index, as a direct result of the drawing, contiguous to—in this case, directly touching—the greasy crayon or greasy ink drawn on the stone. Other print reproductions of drawings are merely icons of the drawings reproduced, inasmuch as they are signs on the basis of their visual similarity to the drawings represented. They are indices of the carved, engraved, or etched line, not the original drawn line.

The slow adoption of the term "lithography" suggests that the significance of the indexicality of the lithographed line was only gradually recognized. From the invention of the technique until 1818, when Senefelder published his treatise *Vollständiges Lehrbuch der Steindruckerey* (A Complete Course of Lithography), the secrets of lithography were closely guarded and there was little consensus on either the nature or the name of the new method. Senefelder was more interested in commercial printing techniques for music, text, and fabric; his name for the invention—*Steindruckerei*, or "stone printing"—emphasized the stone matrix. German writers followed his usage or stressed the chemical basis of the process with the phrase *chemische Druckerei*.[5]

The indexicality of the technique was first accentuated in England in 1803, with the publication of the first series of artists' lithographs, titled *Specimens of Polyautography*.[6] Naming the technique "polyautography," or "multiple original writing or drawing," stressed the originality of both drawing and writing, as well as the reproductive aspect of the print technique. Yet polyautography did not become the standard term: as late as

1807, the technique was still described as "stone etching,"[7] an appellation that could derive from a misunderstanding of the role of nitric acid in processing the stone for printing or from the visual similarities between loosely drawn sketches on stone and the free line of etching. In France the method was described as *gravure sur pierre*, an inherently inaccurate phrase: in French, *gravure* is the overall term for print, but it also specifically refers to the hollowing out of the matrix, whether relief or intaglio.[8] The term that eventually prevailed, *lithography*—literally "stone writing" or "stone drawing"—was first used for Senefelder's technique in France in 1803 and in Munich in 1805. However, the word dates to the eighteenth century, when it referred to engraved stones and gems,[9] and signified the action of the graver on a gemstone.

Although the term lithography was first used in its modern meaning in 1803, the definition was still unstable as late at 1816, as is evident in the report written that year by five members of the French Académie Royale des Beaux-Arts. Despite the authors' understanding of the indexicality of the technique, their language revealed the lack of an established term appropriate to distinguish between drawing, engraving, and the new printing method. The authors frequently substituted *dessin* (drawing or composition) for the term *gravure* (engraving), which the committee considered inaccurate for lithographic prints. Yet they wanted a sign to distinguish the prints from drawings, while simultaneously recognizing the indexical relationship between the drawing on stone and the lithographic print: the tension of these two goals is apparent in the description of the prints as counterproofs *(contre-épreuves)*, lithographic sketches or traces *(tracés lithographiques)*, and autograph engravings *(gravures autographes)*.[10]

The semantic confusion of the Académie des Beaux-Arts committee reflects their attempt to distinguish the indexicality of lithographs from other, already established, iconic means of reproducing drawings. Lithography was only the latest technique used to print facsimiles of drawings for collectors and connoisseurs, and for students and studio workshops. From the sixteenth century onward, chiaroscuro woodblock prints reproduced ink-wash drawings by Raphael and Parmigianino.[11] In the eighteenth century, Louis Bonnet and others used crayon-manner engraving to reproduce drawings by Boucher. Stipple engraving was practiced mostly in England, where Francesco Bartolozzi and his studio reproduced drawings by Guercino and Holbein.[12] For late-eighteenth- and early-nineteenth-century drawing

manuals, soft-ground etching was used to imitate chalk drawings, while aquatint was used to simulate wash.[13] Although some of these printing techniques could produce enviable reproductions of drawings, as engraved or etched copies of the original drawn model they remained icons, signs related to the signified (the drawing) by resemblance, rather than indices, related to the signified by contiguity or direct touch. Of course, lithographs that reproduced a drawing were also simply icons of the original drawing, but the method of reproduction created a second drawing, of which the lithograph was an index.

Of the earlier established print techniques, etching was the most closely associated with drawing and the unmediated expression of originality. In 1806, A. L. Millin stated in his *Dictionnaire des beaux-arts,* "Etching is almost nothing other than drawing and is worked just as easily."[14] Indeed, the etching needle, unlike the engraver's burin, can be readily handled by a novice, and the freedom of movement allowed by the wax ground permits loose calligraphic lines similar to those of drawing. Soft-ground etching is even more closely related to drawing: the artist draws with a pencil on a sheet of paper placed over the ground, and when the sheet is lifted, it picks up the ground wherever pressure was applied with the pencil, allowing the plate to be etched and printed in accordance with the pencil marks. Despite the relatively indexical relationship to the finished print, soft-ground etching, like hard-ground etching, relies on the erosion of the copper plate by nitric acid. In contrast, the lithographic line drawn on the stone is inked directly, and thus the printed line is a mirror-image, indexical facsimile.[15]

In both France and Britain, the indexical relation between lithography and drawing connected the new medium with the associations of drawing as the foundation of the fine arts and source of artistic originality; however, further associations of drawing differed between the two countries. The French centralization of artistic training at the Académie Royale des Beaux-Arts resulted in the codification of various types of drawing, a hierarchy that was readily transferred to lithography. As Albert Boime explains, in the academic system, three main groups of drawing were recognized: the *croquis* or initial thumbnail sketch, the subsequent *esquisse* or more fully worked sketch, and the *dessin*, which encompassed the entire category of drawing but also referred specifically to the composition or pictorial structure. Although the terms would retain their connotations, all three were often used interchangeably.[16] Other types of drawings

produced include *dessins achevés,* or finished drawings, suitable for sale and exhibition as completed works, and drawings executed as models for engravers, typically reproducing paintings.[17]

Of the different types of drawings, preliminary sketches—*croquis* and *esquisses*—were closely associated with the notion of genius. Claude-Henri Watelet wrote: "It is that rapidity of execution that is the source of the fire one sees burning in the *esquisses* of painters of genius; one recognizes here the stamp of their spirit's impulse, one counts its force and fruitfulness."[18] For Watelet, the *esquisse* was the most direct manifestation of the artist's imagination and genius. Nevertheless, the sketch alone was not enough: finished works were the culmination of an artist's talent and skill.

In the 1816 report on lithography by the French Academy, the authors similarly connected drawing on lithographic stone with the expression of genius:

In fact, when the painter draws on stone, he alone invents, executes with the spirit of genius or love or perfection; it is his style, the manner which is proper to him, and even his errors, which he can only derive from himself; there one recovers in his work that rapid, free, spiritual touch, that is the result not of groping, but of the inspiration which drives a creative hand.[19]

A lithograph drawn by an artist displays the free touch of inspiration, unlike the "groping" of a reproductive engraver; and the errors within the print are not the result of an intermediary, but the errors of the artist himself.

Not only could a lithograph reveal the same originality as a drawing, but advocates claimed that it was indistinguishable from a drawing. Godefroy Engelmann, one of the two men who reestablished commercial lithography in France in 1815, called on the expertise of collectors when he wrote: "It is impossible for the most skillful connoisseur to distinguish between one of these [lithographic] proofs and a drawing made by hand."[20]

By arguing that a lithograph and a drawing appeared identical even to the most practiced observer, Engelmann stressed once again the connection between the two media. His assertion was based on the actual physical appearance of the lithograph as a drawing and the appreciation of both drawings and lithographs by educated connoisseurs. Moreover, it recognized the market of connoisseurs collecting both drawings and printed facsimiles of drawings.

Many of the same claims to originality were made in England. Charles Hullmandel, one of the most important British promoters of lithography, titled his technical manual *The Art of Drawing on Stone,* and asserted that the lithograph was not a facsimile, but "the original drawing itself."[21] While eliding the distinction between lithography and drawing, Hullmandel added two claims in support of the printing technique. The first claim carried overtones of liberal politics: lithography allowed the dissemination to a broad public of drawings previously only available to a privileged few.[22] As Ann Bermingham has observed, British drawing manuals of the period frequently claimed to be democratically distributing material previously available only to the elite.[23] Hullmandel's second claim followed on the first:

The ease with which excellent drawing-books and models can now be given to the Public at a cheap rate, will induce many, nay, thousands of parents ... to give to their children a knowledge of drawing; and it is evident that this circumstance must within a few years form a class of amateurs and collectors amongst our rich manufacturers, farmers, and tradesmen, who, but a few years back, never bestowed a thought on the subject.[24]

This mercantile argument indicated that lithography and lithographed drawing manuals were to teach a greater number of amateur artists, who would thus develop as connoisseurs and form a new class of art consumers, thereby expanding the British market for contemporary art. While other techniques could illustrate manuals with prints resembling drawings, the indexicality and cheapness of lithography would teach art more quickly and efficiently.

Lithography's claim to be a transparent sign of drawing was dependent on the similarity of lithographic drawing techniques to already established drawing methods, but the initial technical limitations of the medium threatened to contradict the rhetoric. In order to support the comparison of lithography with drawing, it was essential that the individual touch of the artist be expressed in the prints. Without that, the lithograph had no claim on originality or genius; this direct touch was the crucial, indexical difference between lithography and other means of reproducing drawings. As Antoine Raucourt observed in his 1819 manual, in order to create lithographs with the same facility as drawings, the artist needed materials similar to those to which he was accustomed:

If the only property of a lithographical drawing were to give impressions, almost every fat substance might be employed in lieu of chalk, and every greasy liquid supply the place of ink; but the chief advantage of lithography consisting in giving fac simi-les [sic] of drawings, it is necessary, in order to obtain them, to

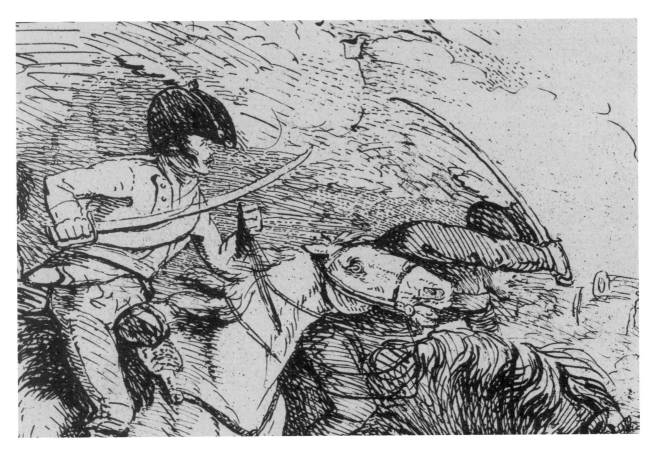

Fig. 18 Gessner, *Cavalry Charge* (detail, actual size), no. 36

furnish the draftsman with ink and pencils similar to those he is in the habit of using; otherwise, by obliging him to employ materials he is a stranger to, you run the risk of cramping his genius, and it might become impossible to recognize his usual spirit and freedom of touch.[25]

Although artists were accustomed to sketching with chalk, pastel, crayons, ink, ink wash, and watercolor, early lithography was limited to lithographic ink and crayon, limitations for which F. E. Joubert denounced the technique: "[Lithography] is nothing but a particular mode of printing, applicable only for drawings made ad hoc, with one ink and special crayons...."[26] Joubert's disdain for lithography was based not only on the material limitations of the method, but also on the lack of finish of these "ad hoc" drawings.

Lithography's sketch qualities and lack of finish were also criticized in England, most notably by engraver John Landseer. Landseer, in his cantankerous *Lectures on Engraving*, warned against the claims of lithography:

The stone etching is calculated, perhaps beyond any art at present known, to render a faithful fac-simile of a painter's sketch. It is

an accession to that sketch itself, if the artist choose to sketch on stone, of the power of multiplying itself to any number that may be required. I must at the same time remark to you, that it is not the painter's sketches, that it is most desirable to multiply, but his finished performances.[27]

For Landseer, the primary issue was finish, and he praised line engraving in moral terms as following "the paths of nature and principle."[28] Consistent with his emphasis on finish, Landseer was vehemently against the aesthetics of the picturesque, extensively criticizing William Gilpin, author of numerous books on picturesque sketching tours of England. Thus Landseer praised reproductive line engraving and railed against all types of prints—stipple engravings, chalk manner prints, soft-ground etchings, and lithographs—that were analogous to sketches.[29]

The earliest lithographs were produced with tusche (lithographic ink), and could be considered drawings in the manner of pen-and-ink sketches. Conrad Gessner's *Cavalry Charge* (no. 36, figs. 3, 18), one of the first lithographs by any artist, reveals both the possibilities and limitations of tusche. Executed during Alois Senefelder's

visit to London in 1801, the print was published in the first artists' portfolio of lithographs, *Specimens of Polyautography,* issued in 1803. Gessner drew the lithograph with tusche, and the shorter pen strokes in the body of the white horse and the rapidly sketched clouds are energetic and capable, successfully conveying drama and motion. In contrast, the longer lines waver hesitantly or are formed by several strokes, as in the outline of the sword at right, revealing the artist's difficulty manipulating the metal pen across the polished limestone. The lithographic ink could be worked with brushes or metal pens, but there was as yet no reliable means to print from ink wash, since the distribution of grease within the wash was difficult to control, and thus the tonality of tusche lithography could not be reliably varied. The inability of early tusche lithography to produce a solid tonal block is emphasized by the selection of a different printing technique, aquatint, for the decorative border of the sheet, original to the portfolio, on which this impression of *Cavalry Charge* is mounted.

Despite the technical limitations of early tusche lithography, another lithograph published in *Specimens of Polyautography* clearly stated the role of lithography as drawing. Thomas Stothard's picturesque *The Lost Apple* (no. 85) stresses the direct connection of artist to print, and the absence of an intermediary engraver. At the lower left, the artist signed his name, followed by the abbreviation *del.,* for *delineavit,* or "drew it," a term found frequently in eighteenth-century engravings, referring to the creator of the model and usually paralleled by the engraver, whose name would be inscribed on the plate followed by the abbreviation *sculp.* for *sculpsit,* or "carved it."

Although critics such as Landseer placed reproductive line engraving in opposition to lithography, artists turned to engraving conventions to create tonal variation. Godefroy Engelmann drew *Old Man Wearing a Turban* (no. 26, figs. 7, 19) during his visit to Munich in 1814, when he first studied lithographic printing techniques. The lithograph is thought to be after a print by P.-A. Wille,[30] and Engelmann probably simply copied the reproductive conventions of his model when he imitated the lozenge-and-dot style of reproductive engraving to create tone. Other artists used engraving conventions for original lithographs. Indeed, Hullmandel recommended the types of cross-hatching used in engraving (although he describes it as etching): "Whatever effect is intended in an ink drawing, it must be done by thicker or thinner lines, crossed in various directions, as in a copper-plate etching."[31]

Tusche lithographs might be considered drawings in the manner of pen-and-ink sketches, but it was the development of crayon lithography that solidified lithography's claim to drawing. Unlike crayon-manner engravings, which imitated the crayon line with roulettes and other mechanical tools, lithography used crayon to create the actual line reproduced, and the lithographic line was virtually indistinguishable from the drawn line. Senefelder first experimented with crayon lithography in Munich in 1799, and continued his experiments during his visit to London, where Conrad Gessner drew several crayon lithographs.[32] However, it was in Munich that Hermann Josef Mitterer firmly established the use of crayon lithography for drawing: as drawing instructor of the Munich Feiertagsschule, Mitterer published lithographed drawing manuals and, beginning in 1805, a series of artists' prints titled *Lithographische Kunstprodukte* (Lithographic Artworks).[33]

In Munich, artists such as Max Joseph Wagenbauer worked with Mitterer and rapidly developed crayon lithographs to a level of skill and tonal range not found elsewhere in Europe until after the Napoleonic Wars. The Bavarian mode of crayon lithography built tone with short, repeated strokes and stippling. Wagenbauer's *Four Sheep, Three Goats* of 1806 (no. 90) is divided into three distinct tonal planes: the far distance is depicted in light gray with short, fine parallel strokes; the middle distance is executed with repeated stippling in which the individual strokes become indistinct, yet the white of the paper and texture of the stone are still visible; and in the foreground, the darkest area of the print displays crayon stippling that has occasionally melded, completely filling the pores of the stone and producing a dense black.

Although lithography was first introduced to France in 1801 by the printer Friedrich André, this initial venture failed, and despite subsequent attempts by other printers, lithography was not successfully established until after the fall of Napoleon, in 1815, when Charles Philibert de Lasteyrie founded a press in Paris and Godefroy Engelmann started a press in Mulhouse, and then in 1816 another in the capital.[34] Encouraged by artist Pierre Mongin, Engelmann introduced lithography to well-known artists, emphasizing its use for original drawings.[35] In a report Engelmann submitted in 1815 to the Parisian Société d'Encouragement, he discussed lithographs imitating engravings and wood engravings, but he stressed above all the possibilities of crayon lithography.[36]

The most eloquent support for the success of lithography as a form of drawing was its ability to produce models for students. Pierre Mongin was the first artist to

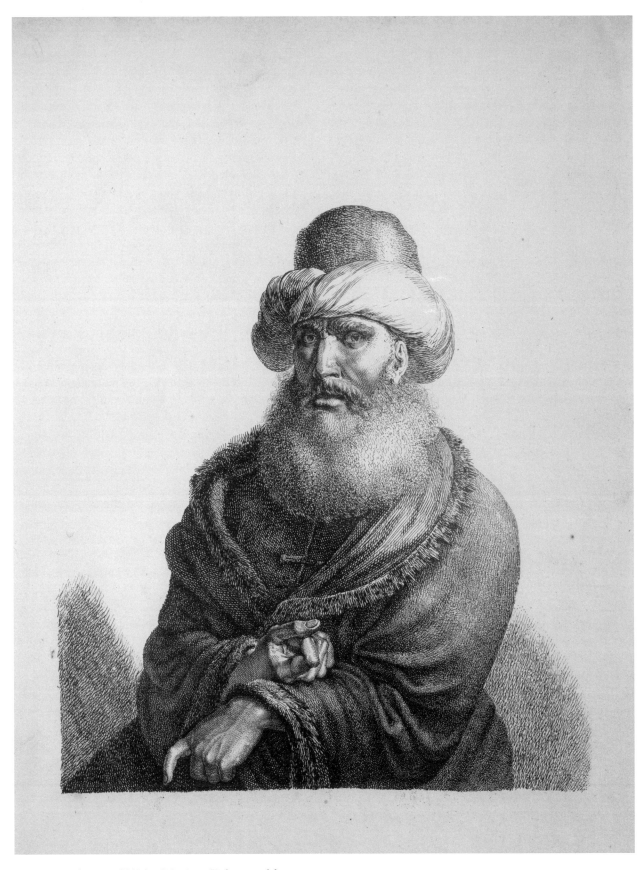

Fig. 19 Engelmann, *Old Man Wearing a Turban*, no. 26

draw lithographs for Engelmann, and one of his early works is *Poplars* (no. 60), part of his 1816 *Cours complet d'études du dessin,* a series of examples for drawing students. The Harvard impression is a counterproof, probably unique, which was produced by placing a sheet of paper over a freshly printed lithograph and running both together through a press, thus transferring the image from the lithograph to the second sheet and restoring the original direction of the image. Recording an intermediary stage in the composition which differs from the final state, this counterproof demonstrates the visual similarity of lithography and graphite. Careful examination of the print reveals that Mongin extensively reworked the sheet in graphite, particularly the rocks and trees at the lower right, presumably to guide his continuing work on the lithographic stone.[37]

The stress on the indexicality of lithography and drawing associated the new medium with debates between neoclassical and romantic artists over sketch and finish, and the role of *dessin.* Although *dessin* in this context usually referred to the composition of paintings rather than to drawing, the word's double meaning and the prominence of the debate inevitably influenced the definition of lithography. As Lucy MacClintock explains, in France the instruction of *dessin* was the source of the Academy's power, and the debate over *dessin* was a struggle over the definition of painting itself. Moreover, the critics who championed the romantic cause were liberals, who had turned to art criticism following the Bourbon censorship of overtly political material.[38] Extending MacClintock's argument to lithography, a highly finished lithographed drawing might carry associations of allegiance not just to neoclassicism, but also to the parallel political position of the monarchist Ultras. Similarly, a loosely sketched lithograph could be aligned with romanticism, and with the republican Liberals.

The self-portrait (no. 67, figs. 20, 21) by Belgian history painter Joseph Odevaere, a student of Jacques-Louis David, uses a highly finished neoclassical drawing style while representing lithography as drawing, and thus one of the fine arts. Standing in front of an easel, with *porte-crayon* poised, the artist shows himself as if drawing on the small lithography stone he holds in his hands. Along the edge of the stone runs the inscription, "J. Odevaere, se ipsum littographice del: parisiis 1816" (J. Odevaere, he drew himself lithographically: Paris, 1816). Placed on the lithographic stone, the inscription refers to the past action of Odevaere in drawing/writing the words, and the action depicted (Odevaere drawing), as well as the production of the portrait itself. Nevertheless,

the reference is merely an illusion: the stone on which this self-portrait was drawn must have been significantly larger and heavier than the stone depicted, requiring Odevaere to rest it flat on a table when drawing. Odevaere chose to depict himself, not in the position he actually occupied while creating the image, but in a conventional artist's pose, emphasizing lithography's kinship with drawing and the fine arts rather than printmaking or the reproductive arts. Furthermore, the large easel in the background, the prominent display of Odevaere's medal on his lapel, and his fashionable dress all proclaim his status not merely as draftsman but as history painter and gentleman. The inscriptions in the margin similarly announce Odevaere's rank as painter, with an elaborate calligraphic presentation of his name and a list of his position and titles, including his appointment as court painter to the king of the Netherlands.

The highly finished style of Odevaere's self-portrait parallels the representation of lithography as a fine art, and emphasizes the neoclassical painting style of the artist. The lithograph has the high degree of finish of a *dessin achevé,* suitable to the subject's status and demonstrating his skill. The background is completely covered with repeated, overlapping cross-hatching, while other areas are created with gently applied stippling that produces the impression of black chalk. The highlights of the coat collar are scraped so subtly that their feathered edges evoke the softness of highlights produced by erasing chalk. The tonal variation and range in the print are even painterly,[39] appropriate to the depiction of an accomplished history painter.

Another early French lithograph, Pierre-Narcisse Guérin's *The Idler* of 1816 (no. 44, fig. 22), combines a finished drawing style with an allegorical representation of the fine arts. Guérin was one of the authors of the Academy report on lithography, and he drew four lithographs around the time of the report. *The Idler* is drawn in a neoclassical style, an *esquisse* with fine diagonals and cross-hatching; it depicts an Arcadian shepherd boy languidly resisting the *putti* calling him to artistic fame and fortune, represented by the painter's, architect's, and sculptor's tools, a laurel wreath, and a horn of plenty. In the background looms the figure of Father Time, with hourglass and scythe. With *The Idler,* Guérin simultaneously presents a suitable neoclassical drawing model for students and an appropriate moral.

Baron Antoine-Jean Gros, David's most successful student and the inheritor of his teaching mantle,[40] experimented briefly with lithography, creating two prints in 1817 depicting exotic subjects with Napoleonic

Fig. 20 Odevaere, *The Artist Drawing on Stone*, no. 67

Fig. 21
Odevaere,
*The Artist Drawing
on Stone* (detail,
actual size),
no. 67

connotations. In *Mamluk Chief on Horseback* (no. 42, fig. 23), Gros employed parallel lines and cross-hatching, and dramatically modeled the musculature of the attendant. The background figures are only briefly indicated, and the sky is blank, much as it would be in an *esquisse*. Although eloquently worked, the style is much looser and more dynamic than the delicate, merging tones of Guérin's print. The tonal range is wider, the strokes stronger, and the construction of the image by hatching and cross-hatching more apparent. Unlike Guérin and Odevaere, Gros did not indicate the edge of the image, suggesting a relative informality appropriate to a preparatory work.[41] The subject matter of Gros's print participates in nineteenth-century orientalism and nostalgia for a pre-industrial past, but for a contemporary viewer, it would also recall Napoleon's Egyptian campaign and the Mamluks who subsequently became Napoleon's bodyguards.[42]

Whereas Baron Gros produced only a few lithographs, romantic painter Horace Vernet was a prolific lithographer who often employed sketch conventions to depict anecdotal street scenes. Vernet's 1818 *Young Man Carrying a Lithographic Stone* (no. 89) presents an apprentice or workman carting a stone in a wooden cradle on his back. This momentary street scene is presented with loose, overlapping contour lines, broadly spaced hatch marks, and visible alterations, conveying the immediacy

encouraged of students in their *croquis* and sketchbooks. Indeed, this may be a proof state of the title page for Vernet's 1818 print portfolio, titled *Croquis lithographiques*, or lithographic sketches.[43] Although the subject matter of this print is apolitical, given Horace Vernet's strong Bonapartist sentiments,[44] the looseness of the style combined with a contemporary Parisian subject may also have signified his politics.

In the years immediately following the defeat of Napoleon and the restoration of the Bourbon monarchy, lithography became synonymous with radical caricature, satire, and political prints attacking royalists and glorifying the Napoleonic past. Political caricatures, usually etchings or rough engravings, had circulated widely during the French Revolution; although heavily censored under Napoleon, they quickly reappeared following the turmoil of 1814.[45] The cheap, quick, and virtually limitless print runs of lithography made the technique ideal for caricature, a genre that had developed from exaggerated Italian sixteenth- and seventeenth-century portrait drawings and that retained close connections to the immediacy of drawing.

As Nina Maria Athanassoglou-Kallmyer noted, monarchists phrased their opposition to lithographic political satires by attacking lithography on aesthetic grounds. In response, the radical newspaper *Le Constitutionnel* mocked the Royalist attitude to lithography:

Fig. 22 Guérin, *The Idler*, no. 44

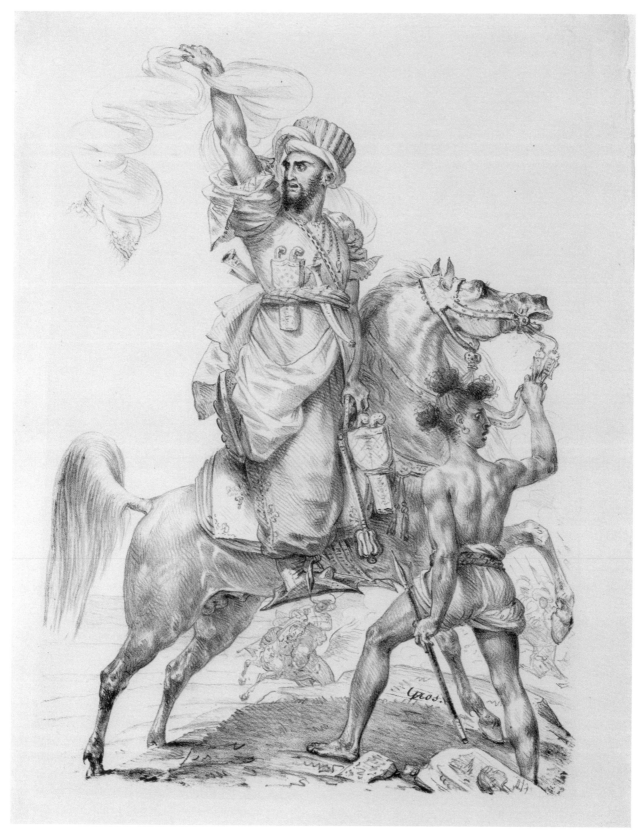

Fig. 23 Gros, *Mamluk Chief on Horseback,* no. 42

Fig. 24 Charlet, *The Flag Defended,* no. 5

A certain political party has such a hatred for anything new, that we would not be surprised to hear our political Tartuffes exclaim, in an inspired tone, on the subject of lithography: "The end of the world is near, the well of the abyss is gaping; the beast of the Apocalypse is loose. Even the stones speak, and recount to the eyes of the entire world the triumphs of the French armies. Lithography, discovered by a Protestant, deals the ultimate blow to religion and good morals: it is a real invention of Satan."[46]

With this account, *Le Constitutionnel* ridiculed conservative opposition to lithographs of caricatures and the Napoleonic army.

While some writers differentiated engraving (including etching) from lithography, the censors saw no such distinction, subsuming both methods under the general category of reproduced *dessins* (drawings or compositions), whose content had to be regulated. Although censorship of caricatures had been abolished in 1814, it was reestablished in 1820, when the French Chamber of Deputies passed a new censorship law stating that "no printed, engraved or lithographed drawings may be published, displayed, distributed or sold without advance authorization of the government."[47]

Early in his career, Eugène Delacroix produced lithographs such as *The Crayfish at Longchamps* (no. 15), which mocked government censorship and was published in the radical journal *Le Miroir* in 1822. Grotesque figures representing the censors and *La Quotidienne*, a right-wing journal, stand on a crayfish, an animal that was believed to only move backwards, exemplifying government reactionism.[48] In contrast to the dynamic yet eloquent line of Gros and the finely modulated tones of Guérin, the handling of Delacroix's print is almost crude. Abrupt strokes, rough hatching, the short blocks for the voluminous skirt of *La Quotidienne*, and the harsh darks of the tusche scattered across the composition create an emphatic style consistent with the radical politics of the caricature.

Among the artists proclaiming in lithographs the tri-umphs of the Napoleonic army, Nicolas-Toussaint Charlet was the best known and the most prolific. Charlet's *The Flag Defended* (no. 5, fig. 24), printed by Lasteyrie circa 1817–18, depicts the Napoleonic army in the heat of bat-tle with the Prussian military. Charlet does not depict a specific battle, but the presence of the *Landwehr*, a Prussian militia founded in February 1813, places this battle among those of 1813–14, or more likely during Napoleon's brief return in 1815, probably the final battle of Waterloo.[49] Rather than commemorating a particular engagement, the lithograph evokes the violence of com-bat and the bravery of both young and old infantrymen from the elite Imperial Guards, who were closely associ-ated with Napoleon. The handling shows the beginning of a specifically lithographic drawing style. Charlet's intricately woven composition of merged tones, worked up to rich darks against the grays of the battlefield smoke, retains an energetic graphic line, with visible hatching and figures delineated by strong outlines.

Although lithography was used for radical caricatures and Napoleonic prints, it could also be turned to more conservative purposes, as demonstrated in the monu-mental series of landscape prints, *Voyages pittoresques et romantiques dans l'ancienne France*, which was organized by Baron Isidore Justin Taylor and subsidized by the French government. This luxury print series combined large-scale lithographs by numerous artists and depicted French churches, castles, and villages, with texts by Charles Nodier relating the history of each location. The first volume was issued in 1820, and twenty volumes were printed over the next half century.[50]

In his introduction to the first volume of *Voyages pit-toresques*, Charles Nodier tried to persuade his readers to associate lithographs with the virtues of artists' sketches rather than the politics of popular caricatures. Referring obliquely to the use of lithography for caricature, Nodier wrote:

The new procedure known under the name of lithography has not obtained the unanimous approval of people of taste; and the prejudice against it is perhaps due to the bad practice that has been made of this invention, as of all new inventions which igno-rance distorts and cynicism dishonors.

He then called on the spontaneity and brilliance associ-ated with the sketch to argue lithography's value:

Freer, more original, and more rapid than the burin, the bold crayon of the lithographer appears to have been invented to fix the free, original, and rapid inspirations of the traveler who real-izes his sensations.[51]

Nodier argued that in comparison to engraving, the freedom and originality possible in lithography made it particularly suited to quick travel sketches. This argument presents the lithographs in *Voyages pittoresques* as original sketches, produced by a single hand. The actual produc-tion of the lithographs differed significantly from these claims of originality. Baron Taylor typically dispatched a handful of artists to tour the provinces, sketching pic-turesque sites; these sketches were then sent to Taylor, who distributed them to other artists to be copied onto lithographic stones.[52]

Furthermore, although Nodier evoked the virtues of the sketch in support of lithography in *Voyages pit-toresques*, few of the highly finished plates in the series utilize line and contour in the spare manner of an *esquisse*: instead, the images resemble watercolors or highly finished drawings. For example, Louis Daguerre's *Ruins of the Abbey of Jumièges* (no. 9) in the first volume of the series displays few contour lines, and crayon is used only to reinforce some darker areas, while flecks of tusche outline architectural details. For the darkest area in the foreground, Daguerre applied tusche in regular diagonals with an extremely fine brush, producing a mechanical line appropriate to line engraving. Using the *lavis lithographique* technique, Daguerre created the effect of a watercolor in the pearlescent tonal range of the sky and ruined abbey church. While the masterful handling has produced a painterly image evocative of a finished watercolor drawing, this lithograph is far from sketch conventions or spontaneity.

Lavis lithographique was developed by Engelmann in 1819 to produce the effect of ink wash or watercolor, usually reproduced by aquatint, an etching process. Engelmann's name for the method recalls both wash (*lavis*) and aquatint (*gravure au lavis*). With this technique, an ink wash was meticulously applied to the stone with a small *tampon*, or dabber, somewhat similar to the padded balls used by printers to ink type. When handled successfully, *lavis lithographique* could produce subtle half-tones, as demonstrated in Daguerre's print. Nevertheless, despite Engelmann's advocacy, the method was not readily accepted. The dabbing motion was unfamiliar to artists, and Engelmann himself later attributed the lack of interest in the technique to the artists' preference for their accustomed crayons.[53]

The more highly finished style of *Voyages pittoresques* parallels the conservative subject matter. Loosely citing the aesthetic notion of the picturesque developed in England in the 1790s by William Gilpin and others, the series celebrated the French countryside as home to

simple folk and beneficent aristocrats. The piety of the people was depicted in religious processions and by the presence of priests, monks, and nuns, while poverty was naturalized and set within the context of noble charity. The romantic focus on medieval and Renaissance monuments enabled the series to recall the chivalrous days of monarchs such as Henry IV and to ignore the tumultuous events of the eighteenth century, particularly the Revolution.[54]

While Nodier, Engelmann, and other promoters continued to conflate drawing and lithography, Géricault, Goya, and Delacroix developed new forms of handling specific to the medium. Théodore Géricault was introduced to lithography in 1817 and rapidly increased his skill, already demonstrating innovative lithography techniques in 1818 with *Return from Russia* (no. 32, fig. 25), a monumental tribute to the Napoleonic army. Unlike Charlet, who depicted heroism on the battlefield, Géricault presented a pathos-filled image of wounded soldiers trudging home across snow-swept Russia. In his handling of the crayon, Géricault follows sketch modes: dynamic, repeated hatching and cross-hatching develop the volume of the two central figures, and the darkest blacks result primarily from increased pressure on the lithographic crayon, although they are reinforced by cross-hatching and by heavy contour lines. In contrast, the lighter-toned background figures are produced by more loosely sketched strokes, with minimal contour lines.

This print was created with two stones, a technique developed in Munich but rarely used in France prior to this date. The first stone was a tint stone printed in ochre, and the second was executed in crayon. This is the sixth and final state of the print, using the second of two versions of the tint stone.[55] The original tint stone had crisp edges, which outlined the soldiers and flattened the image; Géricault may have noticed this awkwardness during the printing process and adjusted the tint stone by brushing the edges of the clouds.[56]

In 1821, while visiting London, Géricault expressed his attitude toward lithography in a letter written to his close friend and fellow artist Pierre Joseph Dedreux-Dorcy:

I have devoted myself for the moment to this genre which, being completely new in London, is unbelievably fashionable. With a little more tenacity than I possess, I am certain one could make a considerable fortune. I flatter myself that these will be no more than posters for me, and that in no time the taste of the true amateurs who are thus becoming acquainted with me will employ me at work more deserving of me.[57]

Although Géricault professed that lithography was merely a useful way to make money, to capitalize on a fashion, and to introduce his work to connoisseurs who might commission paintings, the innovative lithographs he created in London present a different story.

For the portfolio of large lithographs printed in 1821 in London by Charles Hullmandel, Géricault developed a new lithographic manner, one that differed significantly from the sketch conventions used in *Return from Russia*. Hullmandel advised artists to build up lithographic tone gradually, with slow, repeated, overlapping strokes:

In the infancy of Lithography, it was imagined, and asserted, that none but drawings, executed in a bold and free manner, could be successful; but with increased practice and experience, it has been found, that there is no necessity to produce the tint at once, and that a drawing will succeed equally well, and even better, if the tints are produced by going repeatedly over them, and stipling [sic] *them up.*[58]

Géricault followed Hullmandel's advice, yet fused it with a painter's sense of tone and freedom of line. In *The Piper* (no. 33, fig. 26), the dynamic, loose cross-hatching of Géricault's earlier print has been replaced by a closely worked web of overlapping lines. For the sky, Géricault handled the crayon with a light touch, drawing narrow lines that lose their distinctness and merge. Other areas of the print retain their graphic line, but the hatching is more closely spaced than in *Return from Russia*. The intense darks of the tunnel were created with gradually built-up strokes, and Géricault no longer relied on heavy contours to define darker areas. Kate Spencer has stressed the sculptural aspect of Géricault's lithography technique, particularly the intensity of darks built up on the surface of the stone.[59]

Another artist working with Charles Hullmandel was James Ward, and a comparison of Géricault's *The Piper* with Ward's *Adonis* (no. 91, figs. 9, 27), published in 1824, reveals the way both artists used Hullmandel's advice, yet retained the hallmarks of their different training. Ward was an engraver in line and mezzotint, renowned for reproductive prints after paintings by Joshua Reynolds and others. In *Adonis,* a lithograph after one of his own paintings, Ward masterfully built up the tones of the sky with repeated parallel, overlapping strokes and cross-hatching, creating a dense, even texture, in a manner similar to the way in which mezzotint ground is prepared with the repeated overlapping lines of the mezzotint rocker. The broad, dark, sketchy, rippled cross-hatching used for the foreground displays the

RETOUR DE RUSSIE

Fig. 25 Géricault, *Return from Russia,* no. 32

Fig. 26 Géricault, *The Piper,* no. 33

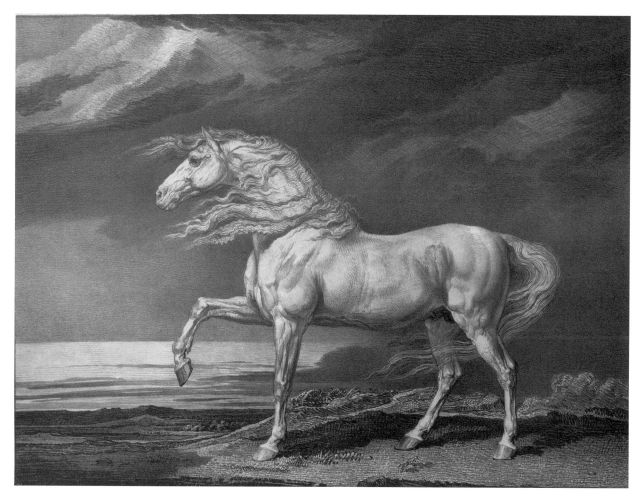

Fig. 27 Ward, *Adonis,* no. 91

texture of the crayon and emphasizes the hand of the artist. Yet, this undulating cross-hatching has a basis in reproductive engraving: it is a looser, freer version of the line Ward used in his engraving after John Singleton Copley's oil painting *Siege and Relief of Gibraltar.* The regularity of the line in *Adonis* retains the trained, mechanical nature of an engraver's line, relying on well-sharpened crayons manipulated evenly, with tight control. In contrast, Géricault's hatching and cross-hatching are variable, using a broader range of crayon widths, producing softer edges, and leaving the impression of spontaneity.

At the same time as he developed a rich, tonal style of crayon lithography, Géricault displayed brief, linear handling in tusche lithography, evident in *Lion Devouring a Horse* (nos. 34, 35) of 1820–21. This lithograph is one of eight that Géricault drew in tusche on "stone-paper," a substitute for the expensive and unwieldy limestone.[60] Composed of cardboard coated primarily with lead

white, the coated paper could only be used for tusche lithographs, and the surface often split or lifted from the cardboard.[61] Comparison of the lithograph of *Lion Devouring a Horse* with the artificial stone reveals that the stone's surface had already deteriorated before this impression was printed: consider, for example, the surface losses in the rocks behind the horse in the drawing and the corresponding area in the lithograph.[62]

Like the other lithographs Géricault executed on stone paper, *Lion Devouring a Horse* is constructed with short, brisk, parallel lines, which he may have chosen for maximum control on the artificial surface. Such brief, parallel strokes and cross-hatching are typical of Géricault's pen-and-ink sketches, suggesting that he may have retained the application of linear pen-and-ink drawing techniques for tusche lithography, even after developing a different approach for crayon lithography. Géricault had also executed his only etching, *Dappled Gray Horse,* circa 1817, with similar short, brisk strokes,

which may indicate that he classified etching together with drawing.

Unlike Géricault, who gradually developed a new, more controlled drawing style for crayon lithography, Francisco de Goya y Lucientes wielded crayon with rough vigor in his monumental series *The Bulls of Bordeaux* (nos. 37–40). Created during 1824–25, while Goya was in exile in France, these four prints display a dynamic, sketchy handling that would be unparalleled for many years to come. With an anecdote that aptly evokes the painterly quality of the series, Laurent Matheron described Goya working with the lithographic stone propped like a canvas on his easel, never sharpening his crayons and handling them like brushes.[63] Goya smoothly covered most of the stone with crayon to achieve a light gray, before energetically scribbling crayon in a range of rough, broad strokes to create the darks. To lighten the gray middle-tones, Goya hatched with an etching needle, in a manner completely unlike the meticulous use of the etching needle recommended by Engelmann and Hullmandel to remove errors invisibly from the stone. To create highlights Goya employed a scraper, producing jagged, denotative lines and strokes that in their crudeness reinforce the grotesqueness of the scenes depicted. This use of the scraper derives from Goya's aquatint methods: in the series *Los Caprichos* of 1799, Goya worked the aquatint ground with the scraper in a similar fashion.[64] Goya's treatment of crayon lithography is also inspired by the texture of ink wash drawings: the figure in white at the lower left of *Bullfight in a Divided Arena* (no. 40) is scratched at an angle to the stroke of the crayon, breaking the crayon mark into a loose texture evocative of the broken sweep of an almost dry inked brush over laid paper.

Whether Eugène Delacroix saw Goya's *Bulls of Bordeaux* series before creating his illustrations of Goethe's *Faust* in 1827 is uncertain; nevertheless, he displays a similar disdain for early lithographic conventions. The dramatic scene in which Mephistopheles appears to Faust is presented in an almost chaotic range of hatching, parallel lines, scribbled darks, and narrow, calligraphic, scraped highlights, fully exploiting the texture of the crayon. In *Faust and Mephistopheles in the Harz Mountains*, the narrow, jagged scribbles produced by the etching needle are the only lines indicating the leaves of the trees.

In the numerous preparatory sketches for the *Faust* illustrations (nos. 17, 18), Delacroix developed the compositions in graphite, pen and ink, ink wash, and watercolor. The range of preparatory drawings reveals Delacroix carefully working out composition, lights and darks,

and specific details, but the final handling of the heavily manipulated lithographic crayon appears to have been explored directly on the stone. This suggests that Delacroix, like Géricault, viewed lithography as a medium with its own effects, separate from those of drawing.

Looking beyond drawing conventions to forms of printmaking, Delacroix was also inspired by the technique of mezzotint. Mezzotint, an intaglio method perfected in the eighteenth century, allowed for a wide range of tonal values and was typically used to reproduce paintings rather than drawings. The image was developed by scraping highlights and middle-tones on a plate prepared with a rough tooled surface that, without scraping, would print black. In lithography, the artist could work in a similar manner by first entirely covering the surface of the stone with crayon or tusche, and then scratching out the highlights.

In his 1825 *Macbeth and the Witches* (no. 16, fig. 1), Delacroix combined the basic concept of mezzotint, of working from dark to light, with line derived from etching. For this print Delacroix first entirely covered the stone with a layer of crayon, then scraped the design with an empty metal pen nib and an etching needle. Whereas mezzotinters used burnishers to create smooth transitions between tone, Delacroix's narrow, jangled lines refuse to merge, suggesting an analogy to the etched line worked on a smoke-darkened etching ground. In an earlier state of this lithograph printed by Engelmann, the porosity of the stone interrupted the darks and threatened to overwhelm the blackness of the crayon, while in the more heavily inked impression of a later state printed by Bertauts, a preliminary yellow tint stone moderated the print's luminosity. By choosing techniques derived from etching and mezzotint, Delacroix downplayed the indexical relation of lithography to drawing, emphasizing instead iconic associations of resemblance to fine prints.

Despite the move away from the clearly drawn lithographic line by Géricault, Goya, and Delacroix, as late as 1830 the prodigious lithographer Achille Devéria used sketch conventions to evoke connotations of genius. In his *Self-Portrait* (no. 21, figs. 6, 28) of 1830, Devéria consciously displayed the drawn line to portray himself, *porte-crayon* in hand, embodying the romantic artist as genius. His intently gazing face is worked in detailed cross-hatching and scraping that devolve into dynamic strokes with the side of the crayon, impetuous contour lines, and ultimately almost abstract, exuberant zigzags. This bravura display of the lithographic crayon emphasizes

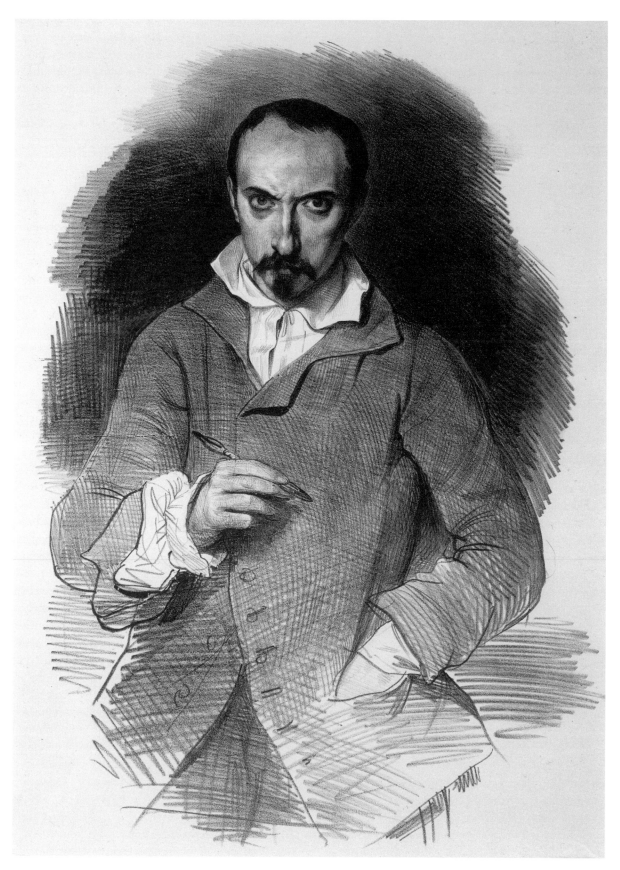

Fig. 28 Devéria, *Self-Portrait*, no. 21

the artist's direct touch and thus reiterates visually the indexicality of drawing and lithography, and the drawing as sign of not only the artist's skill but also his genius. Devéria had turned to lithography to support his parents and siblings, including his younger brother, Eugène, who was a student of Girodet and considered an artist of great potential.[65] In this context, the celebration of drawing and associations of genius by a professional *dessinateur* clearly assert the status of both the artist and lithography.

While the indexical relation between lithography and drawing allowed artists to assert their originality and genius, the medium's commercial success was based on its ability to reproduce images. In a series of articles in 1838 in *Le Lithographe*, a professional journal for printers, Jules Desportes argued that each lithographic print is an original.[66] Again, in 1846, Desportes maintained the equation of lithography and drawing, asserting, "Lithography is nothing but a drawing on stone." Nevertheless, he continued the argument with a list of artists mostly known for reproductive lithographs, which reproduce finished works in other media.[67]

Among the most renowned reproductive lithographs was a monumental series by Johann Nepomuk Strixner, reproducing the collection of the Boisserée brothers, a collection that was subsequently bought by King Ludwig of Bavaria and housed in the Munich Pinakothek. Whereas French artists relied on hatching, cross-hatching, and other linear drawing modes to develop tone, in *Portrait of a Lady* (no. 86) after Lucas Cranach, Strixner used three tint stones together with crayon and tusche lithography to build up soft tonal veils in which individual crayon strokes are no longer visible. The tint stones are subtly manipulated to produce delicate highlights: the lighter yellow stone is gently abraded to produce sparkling white accents across the forehead and nose, and at the bodice the tone is scraped to produce the gleam of satin ribbons. The hair and embroidery details are depicted with fine tusche lines, while in other areas the crayon is built up into deep, velvety blacks. For such reproductions, the role of the lithograph as icon of the original painting is crucial, and the indexicality of the technique is unimportant.

Luxury series of lithographs such as Strixner's *Sammlung Boisserée* and the *Voyages pittoresques* were aimed at wealthy consumers, but the vast majority of lithographs were inexpensive, trivial works, and commercial lithography rapidly became associated with products for the lower classes. Pierre Benoist clearly stated the relative positions of lithography, engraving,

and painting when he wrote in 1839: "Lithography is painting for the people. Oil paintings ... are for the rich; engraving is for the bourgeoisie."[68] Benoist further claimed that inexpensive reproductive lithographs were ideal tools to influence the religion, morality, and patriotism of the people.[69]

The association of lithography with the lower classes, and engraving with the bourgeoisie, explains the use of elaborate engraving conventions for luxury reproductive lithographs such as Aubry-Lecomte's 1826 lithograph after Raphael's *Sistine Madonna* (no. 1, figs. 8, 29). In this large-scale crayon lithograph, Aubry-Lecomte works in complete accordance with line engraving conventions, utilizing lozenges, swelling parallel lines, and regular, mechanical cross-hatching. By citing engraving conventions, Aubry-Lecomte positioned this print as an icon of fine reproductive engraving, suitable for a bourgeois audience, as opposed to the smaller and cruder reproductions for the lower classes. Whereas Engelmann, Prud'hon, and others had earlier turned to engraving conventions in order to create tonal variation not technically possible at the time in lithography, a decade later Aubry-Lecomte quoted engraving techniques for their fine-art associations.

Despite the promotion of lithography as drawing, the technique failed to attract many amateur artists, at a time when amateur drawing was a widespread sign of culture and status. The complete separation of the artist from the actual printing process prevented significant amateur production of lithographs, while other drawing media such as watercolor or chalk were far more portable and amenable. Furthermore, commercial lithography's association with the lower classes impeded middle-class amateur interest in the technique. In contrast, etching—the traditional print technique most closely linked with drawing and the faithful representation of the artist's touch—became the technique most thoroughly associated with dilettantes and women.[70] As Michael Twyman observed, in an 1813 treatise on lithography, Henry Bankes had addressed advice directly to "amateur artists, who may practice the lithographic art for their amusement and the delight of their friends," but by the 1816 edition Bankes had omitted this comment in favor of expanded discussion of commercial processes.[71]

IN THE first three decades following lithography's invention, practitioners and commentators frequently turned to the indexical relation between the drawn line

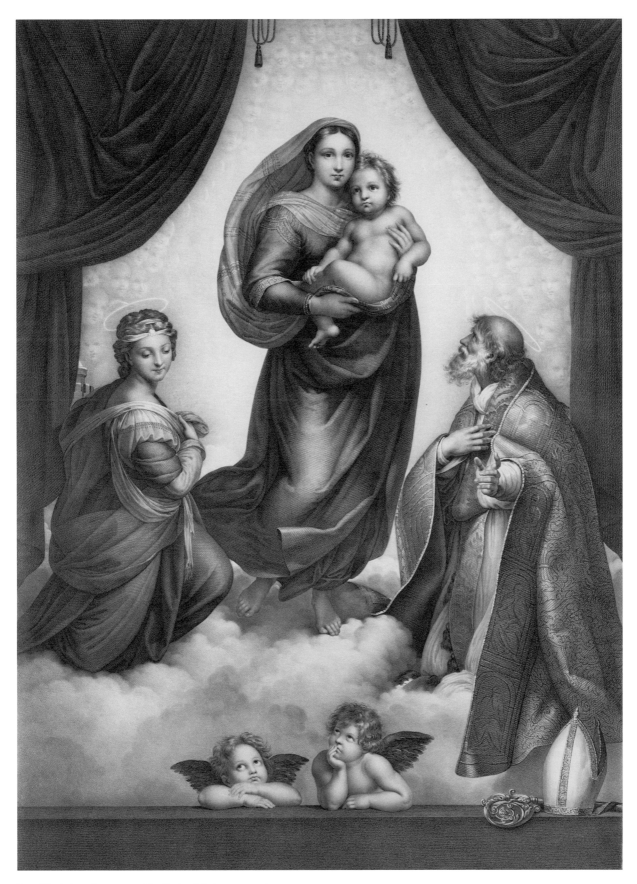

Fig. 29 Aubry-Lecomte, *The Sistine Madonna*, no. 1

and the lithographed line as a means to distinguish lithography from other print methods. Although the rhetorical connection of lithography to drawing continued into the 1820s, artists such as Géricault, Goya, and Delacroix developed more textural forms of handling, freely adapting intaglio techniques to create a new, distinctly lithographic vocabulary. Reproductive lithography also dispensed with overt drawing conventions, as the role of the icon—the similarity to the reproduced painting—overshadowed any role for the lithograph as index. Elaborate reproductive lithographs were eventually valued for their similarity to the controlled line of fine engraving, rather than their connection to drawing. Although advocates emphasized that lithography shared drawing's connotations of originality and creative genius, its association with the lower classes, its commercial success, and its political uses overwhelmed the closeness of the artist's touch.

1. Charles Joseph Hullmandel, *The Art of Drawing on Stone* (London, 1824), v.

2. "Extrait d'une lettre de Loners," *Annals de chime* 41 (30 nivôse an Xe [January, 1802]): 310. For a bibliography of early articles on lithography, see Michael Twyman, *Lithography, 1800–1850: The Techniques of Drawing on Stone in England and France and Their Application in Works of Topography* (London, 1970), 257–62.

3. In this essay I apply Saussurean and Peircian semiotics to my discussion of early lithography. A sign, as defined by Saussure, consists of a signifier—typically a sound, word, or image—and a signified, or concept (Ferdinand de Saussure, *Course in General Linguistics,* trans. with an introduction by Wade Baskin [New York, 1966], 67). For a summary of semiotics and art history, see Mieke Bal and Norman Bryson, "Semiotics and Art History," *Art Bulletin* 73, no. 2 (1991): 174–208.

4. Charles Sanders Peirce, *Collected Papers of Charles Sanders Peirce,* vol. 1 (Cambridge, Mass., 1965), 1.372; Bal and Bryson, "Semiotics and Art History" (n. 3 above), 189–91; Thomas A. Sebeok, "Indexicality," in *A Sign Is Just a Sign* (Bloomington, 1991), 128–43.

5. "Auch ein Wort über Steindruckerey und besonders über das Steindruck: Institut zu Stuttgart," *Morgenblatt für gebildete Stände* 1, no. 293 (1807): 1170–72; no. 296 (1807), 1182–83.

6. For information on *Specimens of Polyautography,* see Felix H. Man, "Lithography in England (1801–1810)," in Print Council of America, *Prints,* ed. Carl Zigrosser (New York, 1962), 97–130.

7. John Landseer, *Lectures on the Art of Engraving* (London, 1807), 143.

8. Compare Claude-Henri Watelet, "Gravure," in *Encyclopédie ou dictionnaire raisonné des sciences, des arts, et des métiers* (Paris, 1754), 7:877–903.

9. Felix H. Man, *Artists' Lithographs: A World History from Senefelder to the Present Day* (New York, 1971), 12, and 12, n. 3.

10. Heurtier et al., "Rapport sur la lithographie, et particulièrement sur un recueil de dessins lithographiques, par M.

Engelmann," in *French Lithography: The Restoration Salons, 1817–1824,* ed. W. McAllister Johnson, exh. cat., Agnes Etherington Art Centre (Kingston, Ontario, 1977), 23–40.

11. See *Beyond Black and White: Chiaroscuro Prints from Indiana Collections,* exh. cat., Indiana University Art Museum (Bloomington, 1989); Susan Lambert, *The Image Multiplied: Five Centuries of Printed Reproductions of Paintings and Drawings* (New York, 1987), 121–45.

12. Arthur M. Hind, *A History of Engraving & Etching,* facsimile of 3rd ed. (New York, 1963), 287–99.

13. Samuel Prout, who later produced numerous drawing manuals with lithographic plates, used soft-ground etching and aquatint for early volumes such as *A Series of Easy Lessons in Landscape-Drawing* (London, 1820).

14. A. L. Millin, *Dictionnaire des beaux-arts* (Paris, 1806), 1:739.

15. Following the drawing on the stone, the lithographic stone is briefly washed with a solution of nitric acid, and then sealed with a solution of gum arabic. These steps clean, then seal the pores of the stone, and do not alter the drawn line, which is subsequently inked and printed. Soft-ground etching, in contrast, relies on the action of the nitric acid to etch the very line that will ultimately be inked and printed.

16. Albert Boime, *The Academy and French Painting in the Nineteenth Century* (1971; reprint New Haven, 1986), 81.

17. For a summary of drawing types, see Petra ten-Doesschate Chu, "Into the Modern Era: The Evolution of Realist and Naturalist Drawing," in *The Realist Tradition: French Painting and Drawing, 1830–1900,* ed. Gabriel P. Weisberg, exh. cat., Cleveland Museum of Art (Cleveland, 1980), 21–38.

18. Watelet, "Esquisse," in *Encyclopédie* (n. 8 above), 5:981. This and all subsequent translations are mine, unless otherwise noted.

19. Heurtier et al., "Rapport," in Johnson, *French Lithography* (n. 10 above), 36.

20. Godefroy Engelmann, "Rapport sur la lithographie introduite en France par G. Engelmann de Mulhausen, Haut-Rhin: Adressé a la Société d'Encouragement de Paris," p. 5 of facsimile reproduction in Léon Lang, *Godefroy Engelmann, imprimeur lithographe* (Colmar, 1977), 145–56.

21. Hullmandel, *Drawing on Stone* (n. 1 above), v.

22. Ibid., iv–v.

23. Ann Bermingham, "'An Exquisite Practise': The Institution of Drawing as a Polite Art in Britain," in *Studies in British Art* (New Haven, 1995), vol. 1, *Towards a Modern Art World,* ed. Brian Allen, 57–60.

24. Hullmandel, *Drawing on Stone* (n. 1 above), xii–xiii.

25. Antoine Raucourt, *A Manual of Lithography,* trans. Charles Hullmandel, 2nd ed. (London, 1821), 5.

26. F. E. Joubert, *Manuel de l'amateur d'estampes* (Paris, 1821), 1:100.

27. Landseer, *Lectures* (n. 7 above), 143.

28. Ibid., 147.

29. Ibid., particularly 123–46.

30. Louis Hautecoeur, "Pierre-Alexandre, le fils (1748–1821?)," in *Mélanges offerts à M. Henry Lemonnier,* Archives de l'art français (Paris, 1913), 440–66. This is a proof state of the print exhibited by Engelmann at the Salon of 1817. Whether this proof dates to 1814 or 1817 is uncertain. R. A. Winkler suggests that the print was drawn in Munich in 1814, and reprinted for the Salon. Compare Winkler, *Die Frühzeit der deutschen Lithographie: Katalog der Bilddrucke*

von 1796–1821 (Munich, 1975), 71, no. 190.5; Léon Lang, *Godefroy Engelmann, imprimeur lithographe: Les incunables, 1814–1817* (Colmar, 1977), 118–19, no. 152; Johnson, *French Lithography* (n. 10 above), 55, no. 11. For discussion of the actual method by which Engelmann approximated the lozenge-and-dot convention, see "The Artist's Touch" by Marjorie B. Cohn in this publication.

31. Hullmandel, *Drawing on Stone* (n. 1 above), 74.

32. Man, *Artists' Lithographs* (n. 9 above), 17–18.

33. Alois Senefelder, *Vollständiges Lehrbuch der Steindruckerey*, 1st ed. (Munich, 1818), 104; Twyman, *Lithography* (n. 2 above), 19–20.

34. For a detailed history of the establishment of lithography in France, see Twyman, *Lithography* (n. 2 above), 41–57.

35. See Mongin's correspondence with Engelmann, published in Lang, *Godefroy Engelmann* (n. 30 above), 33–45.

36. Engelmann, "Rapport sur la lithographie" (n. 20 above), 145–56.

37. Many of the lines in this print have been incised, presumably for transfer. There is no indication of red chalk or any other transfer material on the verso, but an intermediary sheet may have been used. Compare this impression with the published state, reproduced in Johnson, *French Lithography* (n. 10 above), 53, pl. 2.

38. Lucy Marion MacClintock, "Romantic *Actualité:* Contemporaneity and Execution in the Work of Delacroix, Vernet, Scheffer, and Sigalon" (Ph.D. diss., Harvard University, 1993), 4–6, 10–13.

39. Colta Ives, "Lithography's Faces: The First Generation," lecture, Print Council of America Annual Meeting, Boston, 11 May 1996.

40. For an account of lithography in Baron Gros's studio, and of his status as heir of David, see Charlotte Eyerman, "Im Zeichen der *Grande Tradition:* Lithographen im Atelier des Baron Gros, 1816–1835," in *Bilder der Macht, Macht der Bilder: Zeitgeschichte in Darstellungen des 19. Jahrhunderts*, ed. Stefan Germer and Michael F. Zimmermann (Munich, 1997), 176–91.

41. Although lacking a defined edge, Gros's *Mamluk Chief on Horseback* does not display the centrifugal composition and tonality defined as characteristic of the romantic vignette by Charles Rosen and Henri Zerner. Compare Rosen and Zerner, "The Romantic Vignette and Thomas Bewick," in *Romanticism and Realism: The Mythology of Nineteenth-Century Art* (New York, 1984), 73–96.

42. The Mamluks ruled Egypt during the Ottoman Empire and were defeated by the French army at the Battle of the Pyramids in 1798. Following his victory, Napoleon recruited young Mamluks into the Imperial Guard, where they were renowned for their courage and served in all of Napoleon's subsequent campaigns.

43. Twyman, *Lithography* (n. 2 above), pl. 36.

44. For a thorough discussion of Horace Vernet's politics, see Nina Maria Athanassoglou-Kallmyer, "*Imago Belli:* Horace Vernet's *L'Atelier* as an Image of Radical Militarism under the Restoration," *Art Bulletin* 68, no. 2 (1986): 268–80.

45. James Cuno, ed., *French Caricature and the French Revolution, 1789–1799*, exh. cat., Grunwald Center for the Graphic Arts (Los Angeles, 1988); Robert Justin Goldstein, *Censorship of Political Caricature in Nineteenth-Century France* (Kent, Ohio, 1989), 92–101.

46. *Le Constitutionnel*, Monday, 26 April 1819: 4, cited and translated by Nina Maria Athanassoglou-Kallmyer, *Eugène Delacroix:*

Prints, Politics and Satire, 1814–1822, exh. cat., Yale University Art Gallery (New Haven, 1991), 4.

47. Goldstein, *Censorship* (n. 45 above), 105.

48. Athanassoglou-Kallmyer, *Eugene Delacroix: Prints, Politics and Satire* (n. 46 above), 70–71.

49. On the *Landwehr*, see Philip J. Haythornthwaite, *The Napoleonic Source Book* (London, 1990).

50. Twyman, *Lithography* (n. 2 above), 231, n. 2.

51. Charles Nodier, J. Taylor, and Alphonse de Cailleux, *Voyages pittoresques et romantiques dans l'ancienne France* (Paris, 1820), vol. 1, *Ancienne Normandie*, 10.

52. Anita L. Spadafore, "J. D. Harding and the *Voyages pittoresques*," *Print Quarterly* 4, no. 2 (1987): 142. At the beginning of this first volume of the *Voyages*, lithographic redrawings of line sketches of subjects made on the spot are followed, in additional plates, by tonal renditions of the same views, again with one artist working up the image in drawing and another rendering the lithograph, their respective contributions indicated by the plates' inscriptions. Thus Plate 2 is in fact two images, Plates 2a and 2b, inscribed "Croquis d'après Nature J. T. [Baron Taylor, the entrepreneur of the whole scheme], Schnit del.," and "L. Atthalin sculpt., Truchat pinxt," respectively. This double-plate convention was quickly dropped as the volume, and series of volumes, progressed.

53. Godefroy Engelmann, *Traité théorique et pratique de lithographie* (Mulhouse, [1838]), 43.

54. For a discussion of the political implications of the picturesque as developed in Britain, see Ann Bermingham, *Landscape and Ideology: The English Rustic Tradition, 1740–1860* (Berkeley/Los Angeles, 1986), 73–85.

55. For a complete list of the states, see R. S. Johnson International, *19th Century French Prints, Drawings, and Bronzes* (Chicago, 1985), 90, no. 65.

56. Kate H. Spencer, *The Graphic Art of Géricault*, exh. cat., Yale University Art Gallery (New Haven, 1969), 22.

57. Letter dated 12 February 1821, in Charles Clément, *Géricault* (1879; reprint Paris, 1973), 193.

58. Hullmandel, *Drawing on Stone* (n. 1 above), 28.

59. Spencer, *The Graphic Art* (n. 56 above), 10.

60. Géricault owned a one-third interest in a Montmartre enterprise producing artificial lithography stones, and it may have been this establishment that manufactured the "stones" he took to England. See Clément, *Géricault* (n. 57 above), 228.

61. The surface of the artificial stone is mostly lead with traces of calcium and magnesium, according to a spectrographic analysis by William Young, Boston Museum of Fine Arts, 1964. Report in Fogg Museum files, cited in Spencer, *The Graphic Art* (n. 56 above), 25.

62. I am indebted to Clifford Ackley for this observation.

63. Laurent Matheron, *Goya* (Paris, 1858), n.p.

64. *Lithography's First Half Century: The Age of Goya and Delacroix*, exh. cat., Museum of Fine Arts (Boston, 1996), 10.

65. Maximilien Gauthier, *Achille et Eugène Devéria* (Paris, 1925), 10–11; Beatrice Farwell, *The Charged Image: French Lithographic Caricature, 1816–1848*, exh. cat., Santa Barbara Museum of Art (Santa Barbara, Calif., 1989), 47.

66. "Chaque épreuve d'une lithographie est un original," in Jules Desportes, "Dessin au Crayon," *Le Lithographe: Journal des artistes et des imprimeurs* 1 (1838): 98.

67. "La Lithographie n'est qu'un dessin sur la pierre ... ," in Jules Desportes, "La Lithographie considérée dans ses rapports avec les arts, les sciences, le commerce et l'industrie: Necessité et justice de l'admettre au concours de l'École Royale des Beaux-Arts," *Le Lithographe: Journal des artistes et des imprimeurs* 5 (1846): 94.

68. Pierre Benoist de Matougues, "Du Salon de 1839," *Le Lithographe: Journal des artistes et des imprimeurs* 2 (1839): 163–64.

69. Ibid., 165.

70. Compare with Charles Baudelaire's remarks on etching in "Painters and Etchers," in *Art in Paris, 1845–1862: Salons and Other Exhibitions,* trans. and ed. Jonathan Mayne (London, 1965), 220.

71. Henry Bankes, *Henry Bankes's Treatise on Lithography,* reprinted from the 1813 and 1816 editions with an introduction and notes by Michael Twyman (London, 1976), xv–xvi, 16–17.

The "Freedom and Extravagance" of Transfer Lithography

Marjorie B. Cohn

Here is Alois Senefelder, the inventor of lithography, recalling how he had thought up transfer lithography:

Previously I had found that if one wrote on paper with good English lead pencils, then moistened the paper, laid it on a polished stone and passed it through a powerful press, a good impression was the result.... I wished that I possessed an ink that could be used the same way.... Why not make an ink that would leave the paper under pressure and transfer itself to the stone entirely? Could one give the paper itself some property so that it would let go of the ink under given conditions?[1]

And so his printmaking process, which already came closer to drawing than any other, took the last step: it offered the draftsman not only his accustomed tools but also his usual support. The artist could draw on paper and then have his design offset onto a lithographic printing matrix. While in retrospect it is Senefelder's invention of lithography itself—a planographic, chemical printing technique qualitatively different from intaglio or relief techniques—that was his most remarkable discovery, he himself believed that transfer paper "was the most important of all my inventions. It makes it unnecessary to learn reverse writing" (because of the double reverse inherent in first the transfer to the stone and then the printing from the stone). Although transfer lithography was for him primarily of commercial value, he wistfully projected, "Even artists will respect the method when its gradual perfection enables them to draw their pictures on paper with ink or crayon and reproduce them."[2] In fact, the author of an early English lithography manual had already suggested that "The draughtsman, too, may take his paper prepared [with gum tragacanth and starch] into the country, make his sketches, and at his leisure transfer them to the stone, without the trouble of reversing the subjects...."[3]

Many years would pass before artists accepted transfer paper, in part because the coatings that enabled reliably successful transfers, which preserved the texture and detail of the drawings, would not reach their "gradual perfection" until the second half of the nineteenth century. In the interim the transfer lithograph was used

as Senefelder foresaw, as a kind of proto-photocopy. In Léon Gozlan's novel *Aristide Froissart* (1844), a woman asks a lithographer, "[C]ould [you] make one of your presses available immediately to lithograph a circular, whose contents I shall write down for you?" "Certainly, Madame, ... I'll prepare the stone while you are writing...."[4] This exchange suggests the use of transfer paper and normal writing; the calligraphic skills required to write backwards were developed only by professional engravers of inscriptions on intaglio plates, a tradition that transfer lithography (and then photolithography) would eventually extinguish.[5]

An amusingly symmetric counterpoint to the incident in the novel is provided by a description of the twentieth-century painter Helen Frankenthaler: "Working at ULAE in the early 1960s, she tried to preserve the spontaneity of her canvases by working quickly and impulsively, 'discarding stones like typing paper.'"[6] Transfer paper would have been far easier to use because another of its charms, especially for the neophyte, is its unintimidating flimsiness;[7] but at that moment ULAE (Universal Limited Art Editions) and, across the American continent, the Tamarind Lithography Workshop were instigating a revival of artistic lithography. They required adherence to the myth of the stone (although they used transfer paper when expedient),[8] just as abstract expressionist painters like Frankenthaler were uncompromising in their initial resistance to the deflections of print processes.

From the vantage of a more liberal print workshop at the Nova Scotia School of Art and Design, Eric Cameron observed that "Tamarind's [contribution to the American print renaissance] like all renaissances was essentially a revival of past values, while, in the meantime, the development of art on a broader front had called into question the presuppositions on which these values were based."[9] In fact, in lithography there was already a long history of conflict between "past values" and "the development of art" centering on transfer paper, which at the beginning of the twentieth century had even resulted in a suit for slander.[10]

The basic question was the originality of a transfer lithograph, which could and often did look so like the artist's drawing—in its media as well as its technique and style—that, while for some it was the most authentic possible original print, for others it was ineluctably a reproduction.

The earliest identifiable transfer lithograph in this exhibition, Philipon's *Louis Philippe Transforms into a Pear* of 1831 (no. 70, fig. 30), embodies the contradiction. In his magazine *La Caricature,* Philipon had published a political cartoon featuring a gigantic pear that looked suspiciously like King Louis Philippe. Hauled into court on the charge of *lèse majesté* (violating the dignity of the king), Philipon drew a sketch on the spot in support of his innocent plea, but to no avail: he was sentenced to six months in jail and a fine of 2000 francs. Ten days later a lithograph (the one in this exhibition) appeared in the magazine.[11] The artist's own title at the top of the sheet—*Sketches Made at the Hearing of 14 November*—suggested that it was a drawing, or at least that the artist had taken a sheet of transfer paper to the hearing and drawn his lithograph there. In fact, however, the drawing that Philipon made in the courtroom (now in the collection of the Bibliothèque nationale) bears four sketches of the head/pear, but not the ones that are the substance of this print, and it does not have the inscriptions that comprise most of the print's content, concluding with the terse "procès du journal La Caricature"—"trial of the magazine *La Caricature.*"

The final paragraph of the inscription summarizes the argument that Philipon must have offered verbally at his trial: "Therefore, for a pear, for a brioche, for all the grotesque heads in which chance or malice may have placed this unfortunate likeness, you could inflict on their author five years in prison and a five-thousand-franc fine?? Admit, sirs, that this is a singular liberty of the press!!"[12] Philipon's disingenuous citation of the maximum penalties when he already knew he had received less would have corroborated for his readers the lithograph's authenticity as a sketch made on the spot, as would the script, so fluent that it could not have been written in reverse.[13]

To consider lithography's further resources in creating an illusion of an original drawing, we should note that Philipon printed his *Sketches Made at the Hearing of 14 November* on a hard-surfaced laid paper, a sheet which even retained its deckle edges (the ragged edges of fibers on a full sheet, which also signify "handmade")—in a word, on *drawing* paper. Because of the devotion of adepts of stone lithography to the stone's grain, its

absence in transfer lithography and its replacement by the grain (or lack of same) of whatever paper the transfer lithographic draftsman had employed became a major issue. Walter Sickert declared in his review of an exhibition of transfer lithographs by Joseph Pennell:

Aesthetically, the crown and glory of the lithograph is the range it affords, from the whiteness of the paper down to the most velvety depths of the black ink. This range is expressed in terms of the Bavarian stone. Here, then, is a beauty, half natural, and half due to human skill, which is the attribute of lithography alone. When the drawing, however, is made on transfer paper, the range of color is restricted by about two-thirds, and it is expressed in terms of an artificial grain.... it is nonsense to talk of lithography on these terms. It is in full decadence.[14]

One tactic to counter the lack of stone grain was the one taken by Philipon. He used laid paper for the finished print, so that the actual paper texture subliminally suggested the authentic hand of the artist. Laid paper, with an inherently ribbed surface, had been the only sort manufactured from the introduction of paper into Europe in the twelfth century up to the invention of wove paper in the middle of the eighteenth. Displaced by wove paper for commercial uses—in particular for stone lithography, where the smooth, wove surface enhanced the effect of the stone grain—laid paper came more and more to signify handmade art, specifically drawing, in the nineteenth and twentieth centuries.[15]

Nowhere is the use of fine laid paper for printing a transfer lithograph so evocative as in the Fogg's impression of Whistler's sketch of his sleeping invalid wife (no. 93, back cover). "Lithographs drawn on transfer paper were as immediate to him as the drawings in his ... sketch-books. When he was under particular emotional stress—as ... before his wife's death in 1896—he was able to work in that medium, even when unable to cope with others."[16] Whistler had this particular impression printed as if it actually were a page from his sketchbook: he chose a sheet of laid paper from an old book, removing it whole so that it retains notches from stitching at the left edge and the subtle browning at the top, right, and bottom edges that indicates that the sheet came from a bound volume.[17] Confronted with such an ineffable integration of paper and printing ink, it is difficult not to lose patience with Bolton Brown's sanctimonious dismissal of Whistler in his paean to "drawing on stone—the most perfect of surfaces": "Whistler, Pennell and Fantin-Latour ... were, none of them, lithographic draughtsmen, in the true sense, ... once they abandoned the physical basis of that art."[18]

Fig. 30 Philipon, *Louis Philippe Transforms into a Pear,* no. 70

Fig. 31 Degas, *Nude Woman Standing, Drying Herself,* no. 12

Fig. 32 Pennell, *Oil Refining, Whiting, Indiana* (detail, actual size), no. 69

Lithographs by Edouard Manet (no. 56, frontispiece) and Edgar Degas (no. 12, fig. 31) on exhibition, printed on laid papers with deckle edges, may have had their designs applied to the printing matrix by a process even more outré than transfer paper: they may have been drawn on transparent supports such as gelatin film or glass and transferred onto a photosensitive lithographic surface by exposure to light.[19]

Another response to the stone grain issue concerned the texture of the transfer paper itself. Regardless of the surface on which transfer lithographs are eventually printed, the laid pattern (or any grain) in the transfer paper replicates in the image. Pennell, the chief proselytizer for transfer lithography, would select laid papers for his drawings, even sheets not specially treated for transfer (which required expert care by the printer to achieve a satisfactory result). Pennell was not indifferent to the visual indigestion that differing textures in transfer and printing papers might cause, such as that seen in

Bread! by Käthe Kollwitz (no. 54), a transfer lithograph drawn on a smooth-surfaced sheet but printed on laid paper with deckle edges. For his *Oil Refining, Whiting, Indiana* (no. 69, figs. 32, 43), Pennell cleverly selected the identical paper for drawing and printing, and his printer made every attempt to align the real chainlines with the reproduced ones. Only by examining the sheet carefully by transmitted light can one see that the texture of the print is displaced about two millimeters from the texture of its paper.[20]

Matisse habitually used transfer paper, "which dispensed with any contact with the stone and kept him in the role of pure draftsman."[21] In his *Crouching Nude* (no. 58), for which he utilized a typically slick, coated transfer paper, a smooth-surfaced paper was chosen for printing; his greasy, clotted crayon line harmonizes perfectly, and only the entirely different facture of his signature and edition numbering gives the work away as a print and not a drawing.

Other artists took the opposite tack and exploited differences in texture between the transferred image and its printing paper. On the sheet music cover for *Ubu Roi* (no. 46, fig. 33) (which also illustrates transfer paper's capacity to reproduce scrawled handwriting), Alfred Jarry deliberately rubbed his crayon over a rough substrate to achieve a coarse cloth texture appropriate to his shockingly primitive drawing, and in violent contrast to the bland, commercial wove printing paper. Yet the crude lithograph and the inartistic paper combine in a metaphoric visual iteration of *"Merdre"* [sic], the first word flung by Ubu Roi at the theater audience, a public more accustomed to the discretion and elegance of the aesthetic movement.

Another lithograph from the same period also carries a transfer from cloth, though this betrays a private obsession that probably went undetected in its time. In a later state of his lithograph of the beautiful concert violinist Eva Mudocci (no. 64), Edvard Munch added the texture of the dress she wore, apparently from a transferred rubbing of the actual textile itself. To quote Elizabeth Prelinger, who first noticed this odd detail, "Such additions enhance the fetishistic character of this imposing portrait."[22]

Even three-dimensional forms might be transferred: Max Ernst found the form of his *Elektra* (no. 28) in the shape and surface of a decorative carving. For Ernst, "Printing was the magic touch that smoothed over the joints and left no hint of the handiwork involved,"[23] and transfer lithography accommodated his favored method, frottage (a rubbing process).

The most extreme application of transfer lithography was conceived by Jean Dubuffet, who eliminated drawing entirely. In his own words,

[A]ll lithography is based on the principle of printing and the transfer of prints.... So I had the impression, most satisfying to me, that in approaching lithography with bare hands, using no tool other than the roller, I espoused its own methods, that I entered more wholly into its discipline, more than by cautiously drawing on the stone. At times I took impressions of any element I came across and found inviting—earth, walls, stones, old suitcases ... a friend's bare back ... In some cases, I arrived at interesting impressions by passing the inking roller, not directly over the object, and then pressing the sheet over it, but over the paper itself covering the object.... But never brush or crayon. To allow their intrusion seemed shocking to me, actually to go against the very nature of this work.[24]

He planned to print his textures in combination, in color, and eventually did; but "[a]s soon as the first key

plates ... appeared as individual proofs in black, my imagination caught fire.... Although I first had no intention of making these plates for their own sake, but only so they could be used for the superposition of colors ... they seemed extremely suggestive.... " He ended by making "thirteen albums of plates printed in black which I like to think of as a kind of dictionary of Texturology." Dubuffet and his printer gave the lithographs poetic and suggestive titles "more meaningful to the memory than an ordinary number," but one suspects that *Rectilinear Traces* (no. 25, fig. 34) was a "dictionary" entry taken from an old suitcase.

Artists could even create variations in texture within the transferred image by moving the sheet from one supporting surface to another while drawing. The cataloguer of Fantin-Latour's lithographs reported on the artist's developing appreciation for transfer lithography:

At first, in making his drawing on transfer paper instead of executing it wholly and directly on the stone, M. Fantin thought only to avoid the inconvenience of the slabs, always in the way and unmanageable, ... but he saw almost immediately that this method would have many other advantages for him.... By laying his tracing over one and then another paper with more or less grain, he could now obtain at will all the inequalities or unity of surface required by his intentions....[25]

Textural complexity is the basis for the delicate changes of tone and mood among the fifty plates of the haunting *Barcelona Suite* by Miró. All black and white, all populated by the same race of humanoid creatures, astral symbols, and erotic forms, they could have become monotonous; but the variety of line and surface developed by the artist's selecting and even creating different surfaces on which to lay his transfer paper instead produced an infinitely various universe. For example, in *Plate XXIV* (no. 59, figs. 13, 35), at the lower right, juxtaposed with an area bearing the fine-grained weave of a painter's canvas, is the printed rubbing of a rough passage of painter's ground into which Miró had cut a channel, which in the print appears white against the mottled texture that surrounds it. The artist then drew on the transfer paper a positive black form within the white channel, so that the black stick figure is surrounded by an aureole of white and gray. The more closely one inspects every area of the sheet, the more resources enabled by transfer lithography can be discovered.

For the print on exhibition from Kurt Schwitters's *The Cathedral* (*Die Kathedrale*, no. 83), instead of moving his transfer paper about on different textures, the artist first

Fig. 33 Jarry, *The Debraining Song* from *Ubu Roi*, no. 46

Fig. 34 Dubuffet, *Rectilinear Traces,* no. 25

Fig. 35 Miró, *Plate XXIV* (detail, actual size), no. 59

created a collage of surfaces—"bits of waste from the contemporary urban environment"[26]—which, together with the fasteners that hold them together and the disjunctions of level their combination produced, are replicated in the lithograph.

It was only a short step in transfer lithography from working *on* collages to working *with* collages, and an easy one for Picasso, the inventor of collage as an art form. When he returned to lithography in 1945, many years after an early, relatively unproductive foray, instead of drawing directly on stone at the printer

Mourlot's shop, "... Picasso produced a rather grubby little collage of cut-out shapes of transfer paper covered with lithographic ink. To Mourlot's surprise and Picasso's 'visible stupefaction,' Gaston Tutin [who prepared the stone for printing] ... pulled an exquisite proof."[27] This first try, *Head of a Woman* (no. 71), was followed by more elaborate compositions, such as *Still Life with Stoneware Jug* of 1947 (no. 72). Picasso rubbed a rough texture onto a piece of transfer paper, crayoned over another piece till it was black, cut them into shapes, and pasted them onto a full sheet. He then drew sufficient crayon lines to

Fig. 36 de Kooning, *The Marshes,* no. 14

Fig. 37 de Kooning, *The Marshes* (detail, actual size), no. 14

snap the still life into spatial presence, and the collage was offset onto a stone for printing.

A more utilitarian collage transfer is seen in Munch's design for an exhibition poster. He took his woodcut *Man's Head in Woman's Hair* and, following a collage mockup of his design (no. 62), had a transfer made of the woodcut onto a lithographic matrix. He reworked the design in crayon, adding lines that he had painted in crimson wash against the scarlet background of the mockup. The crayon lines, along with the transferred woodcut heads, now print green against the red background of the poster, but their function, to suggest the woman's breast pressing against the man, remains the same (no. 63).

Willem de Kooning exploited collage in transfer lithography more creatively. Although he had experimented with tusche lithography directly on stone in 1960, he did not take to the technique. It was not until 1970, urged on by his dealer, that he tried transfer lithography. He had begun making collages in the late 1960s, and it seemed natural to tear up tusche-washed sheets of transfer paper and reassemble them into compositions. An attentive look at *The Marshes* (no. 14, figs. 36, 37) reveals that the artist has integrated into darker areas of the print the ragged white lines made by the edges of the collage elements, so that his gestures in both painting and tearing are represented.[28]

Let us return to the description of Fantin-Latour's appreciation of transfer lithography, and a further point about its usefulness. "By laying his transfer paper onto a drawing or lithograph that was already done, or even onto a painting, he achieved another goal no less in

accord with his inclinations. Quickly, practically without effort, he could pick up an earlier composition again, and in changing it, try, work, caress his idea at leisure."[29]

The use of tracing paper to repeat and develop compositions was a standard academic drawing technique, and its adaptation to lithography was an easy transition. No one exploited it with greater persistence, in drawing and in lithography, than Degas. He was quoted as saying, "Make a drawing. Start it all over again, trace it. Start and trace it again."[30] This is exactly the technique he used in the successive prints and states of prints of his *Leaving the Bath* (no. 13), with both transfer lithography and photographic transfer[31] added to tracing to enrich the process.

Ironically, the transfer lithograph by Fantin-Latour on exhibition here, *Inspiration* (no. 29), shows none of the subtle complexities that would be expected from such lengthy processes. After the artist completed on paper the equivalent of the patient labor on stone advocated by the opponents of transfer lithography, he had to turn his design over to a printer, who offset it onto a zinc plate. Disaster struck:

[R]arely had the artist pushed and caressed his drawing to such a degree; halftones of extreme refinement blended, one into the next, in the flesh, the draperies, the sky. The press crushed all that; the processed plate returned only clots of black. No doubt the print, even as it is, remains desirable. The attractive drawing, the power of the figures, the inherent concept could not vanish; but one does not even suspect the finesse that had joined them.[32]

Though it is the position of this exhibition and catalogue to focus entirely on the contribution of the artist to the finished lithograph, and to ignore the essential contribution of the printer, in the case of transfer lithography it must be clearly stated that the benefits of the method are gained at the cost of yet one more step that can compromise the complex process of producing a print.

It has been observed by Antony Griffiths that *The Acrobats* by Paul Klee (no. 53) was also damaged in transfer. Griffiths described the artist's process:

[W]hen he copied [a drawing he had made three years earlier,] he must have felt that something more was needed and so traced it through a sort of "carbon" paper onto the transfer paper ... the effect [in the lithograph] was at least partly spoiled by the acrobat's right foot having failed to transfer. Although this print was published in a large edition ... Klee never corrected the stone.[33]

Yet one wonders: perhaps Klee found the precarious little figure enhanced by the loss of its balancing foot,

and took advantage of the defect in the transfer process. "Spoiled" is relative, only referring to the precedent of the drawing and not to the creative potential of an accident, as realized by an imaginative artist. There is no doubt, however, that the more complicated the original, the more likely it is to be diminished by transfer onto the printing matrix. This was certainly the case with *Inspiration*, where Fantin-Latour was heavily invested in the drawing process itself. One cannot imagine Philipon's pear king suffering comparably.

That having been said, let us turn to the earliest significant exploitation of transfer lithography's capacity to replicate both the linear composition and the textural effects of drawings—a project that did not initiate new works but rather made a conscious facsimile of its prototypes. In 1864 Alfred Robaut published *Eugène Delacroix: Facsimile de dessins et croquis originaux.* Comparison of the original drawing *Tiger Drinking* (no. 20), which is itself a tracing from a canvas, with Robaut's transfer lithograph (no. 81) shows the amazing fidelity of line that Robaut could achieve by working over a comparably textured surface. In addition, Robaut did not have to cope with reversal of the image. Curiously, when the publication was hailed by one of the most eminent connoisseurs of the day, he said that "the facsimile costs only a few francs and is as faithful as a reflection in a mirror," not recognizing that transfer lithography is *more* faithful than an image in a mirror, because it is not reversed.[34]

Enchanted with the artistic success of transfer lithography, Robaut next applied it to a portfolio of lithographs drawn by Camille Corot, who, showing remarkable openness toward nontraditional graphic processes, had earlier experimented with photography as a means of making multiples of his sketches. His *cliché-verre* plates[35] had met with no popular success, and the portfolio *Douze Croquis & Dessins Originaux sur papier Autographique par Corot* was likewise a commercial failure, perhaps because, despite Robaut's conscious limitation of the edition to only fifty copies, collectors were still unable to reconcile a multiple with the concept of the original drawing.

For Robaut, a transfer lithograph such as Corot's *Sappho* (8, fig. 38), printed in sanguine to enhance the association with Conté crayon, embodied "the intimate work of the Master, without any sort of intermediary, & we insist on the significance of this procedure, for there is in the work of an artist such as M. COROT, an indefinable aspect of poetry which no alien crayon would know how to render."[36] *Douze Croquis* has since been recognized as "the first publication of original

Fig. 38 Corot, *Sappho,* no. 8

prints to embody the new aesthetic of ... lithography as a means to multiply drawings rather than as a medium to be exploited for its own unique resources."[37]

In fact, one of Corot's original drawings for transfer has, almost miraculously, survived (no. 6, fig. 39). Paired with the corresponding lithograph (no. 7, fig. 40), it demonstrates the amazing fidelity of the transfer process, and it also reminds us that the active agent in the transfer was not the pigment in the artist's crayon but rather the grease. The crayon's binder generated the intensely black printed image, which could have been, as in *Sappho,* an intensely colored one, depending on the choice of printing ink. The drawing medium was perhaps attenuated by the transfer process, but it seems doubtful that it ever read as strongly as its image does now in the lithograph. Also, the sleek, white *chine collé* sheet onto which the sketch was printed provides a much more vigorous

contrast than the coated transfer paper (which may have yellowed with age). Seeing the drawing and print side by side, we are encouraged to consider their differences. Had we only the lithograph before us, we should think it the epitome of the freehand sketch.

This aesthetic is recognizable throughout the variety of transfer lithographs on view. Even within the restricted genre of crayon transfers, diametric opposites such as Corot's soft, loosely coalesced patches of tone and Ellsworth Kelly's rich, sinuous contours, as in *Locust (Acacia)* (no. 50, fig. 41), demonstrate the fidelity as well as the range of the process. Kelly himself considers his use of transfer lithography more a question of vision than touch. Given his, and our, ingrained habit of "reading" images from left to right and bottom to top (that is, near to far), the subtle inflections of his lines that cause silhouettes suddenly to resolve into objects in space

Fig. 39 Corot, *The Encounter in the Woods,* no. 6

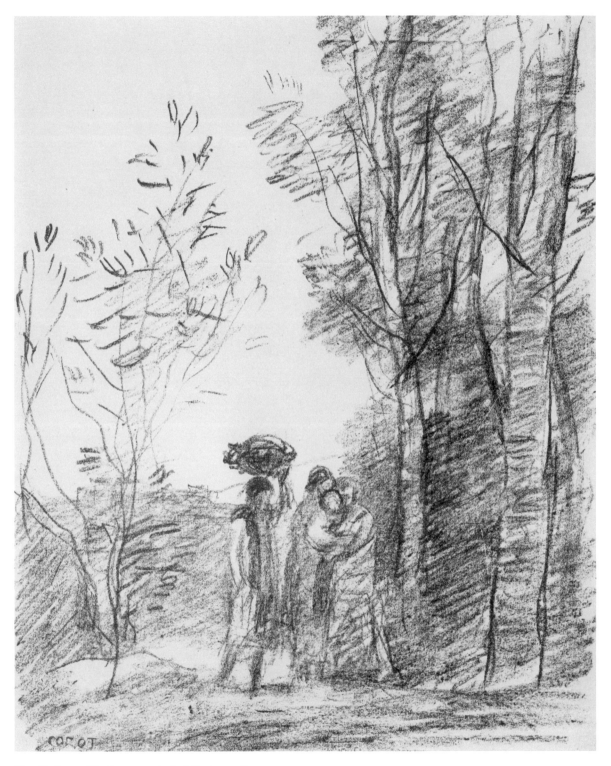

Fig. 40 Corot, *The Encounter in the Woods,* no. 7

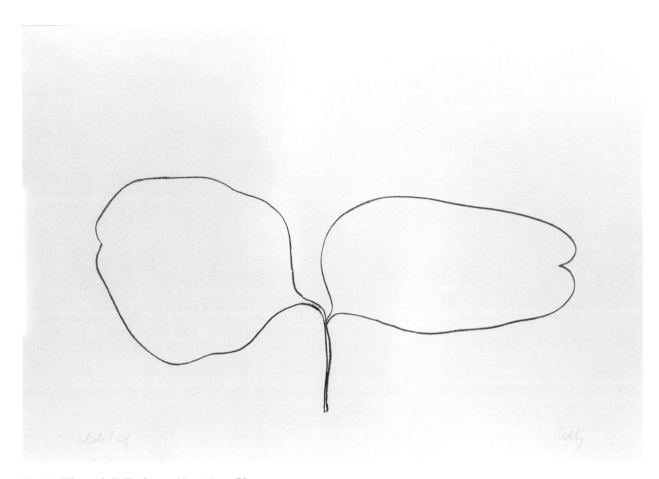

Fig. 41 Ellsworth Kelly, *Locust (Acacia)*, no. 50

simply would not work if reversed. While the expediency, the disposability, of paper over stone or plate is not irrelevant to Kelly, he values even more the exact correspondence of transfer lithography to the eye/hand intimacy of drawing.[38]

RESENTMENT against transfer lithography was at its peak in the early twentieth century, among artists and critics who had been nurtured in the heyday of the international Arts and Crafts movement's ethos of truth to materials. Ernst Ludwig Kirchner (referring to himself in the third person) succinctly expressed the focus of the opposition: "He has never worked on transfer-paper, from which unfortunately the majority of lithographs are made today, which makes them no more than reproduced drawings...."[39]

And these advocates for stone lithography hated the transfer process for its seductive convenience, especially as realized by Whistler and Pennell, who neglected the resources that could be developed only by patient labor on the stone. It was the grasshopper and the ant all over again. F. Ernest Jackson pontificated in a conservative journal for print collectors: "Lithography is not merely a means of repeating copies of a rapid sketch; it is a printing medium, and should be sedately used...."—this to readers wholly familiar with the antics of Whistler and polemics of Pennell, who were personally anything but sedate. Jackson conceded that "Qualities of a kind can be obtained from lithographic transfer paper, but the best use of the transfer ... is as a basis for a stone drawing."[40]

This in fact seems to have been the tactic of Odilon Redon, that *"grand adepte"* of transfer paper who said, "The whole future of lithography (if it has one) lies in resources yet to be discovered in this paper, which so perfectly transmits to the stone the most delicate and transient inflections of the mind. The stone will become passive."[41] Yet examination of a unique first-state

impression of the plate on exhibition from Redon's *Apocalypse de Saint-Jean* (no. 77) revealed to a modern scholar "that Redon had sketched only the barest outlines of this image on transfer paper before its placement on the stone ... the entire composition was radically transformed, during numerous further stages of redrawing ... in the lithographic workshop."[42] The role taken by Redon's stone was anything but passive, and one must attribute to his work on the stone the immeasurable depths and variety of blacks that this lithograph displays.

Inevitably, we must return to the criticism of transfer lithography voiced by Sickert: "Aesthetically, the crown and glory of the lithograph is the range it affords, from the whiteness of the paper down to the most velvety depths of the black ink.... When the drawing, however, is made on transfer paper, the range of color is restricted by about two-thirds...." The single objective measure that we can offer here is the comparison of two lithographs by Rudy Pozzatti, part of a little suite called *Bugs*.

Pozzatti drew his insects on stone, and *Five Wooly Bears* (no. 74, fig. 42) does indeed display a full range of tones, from the paper color (here buff, not white) to the most velvety depths. Also evident on this very small page is the enormous range of drawing methods available to the lithographic artist. There is no crayon to be seen, but brush (applying both tusche and gum arabic stopout, to read black and white), an atomizer, and even the artist's fingertips have formed the image. As Pozzatti has said, "Of all the print media lithography lends itself best to the natural way of drawing...."[43]

The colophon, however, was drawn on transfer paper in order to accommodate the necessary text in the artist's own handwriting. Here too the artist used his fingertips, as well as brush, reed pen, and tusche to lay out the monstrous dragonfly that straddles the documentation of the edition. When the prints are not under glass, one can see that the darkest areas of the colophon are not so dark and velvety as, for example, the shadow surrounding the lowest caterpillar in *Five Wooly Bears*. Yet the difference is hardly discernible, and it is certainly not the diminution by two-thirds stipulated by Sickert. The rich blacks of Blatherwick's *Blown Poppies* (no. 2), Pennell's *Oil Refining* (no. 69, fig. 43), and Matisse's *Crouching Nude* (no. 58)—transfer lithographs all—likewise counter his claim.

Finally, we must weigh any loss of the stone's potential for velvety blacks and modulated tones against the positive gain in freedom of draftsmanship for the artist, even if, as here, only in the simple ease of writing a text

that is perfectly integrated with a bug. To take a grander example, Kelly's unfettered strokes in *Locust (Acacia)* (no. 50, fig. 41) would not have been possible were he constrained to work on stone, just as the "sorcery" evident in Delacroix's *Royal Tiger* (no. 19) entailed repeated reworking on stone (see p. 15 above).

Bolton Brown was correct: "When Mr. Pennell writes that you can do anything on paper that 'you can do on stone,' he writes what is not true. If this statement were true it would be a very important truth, but as it is not true, it becomes simply an important lie."[44] Likewise correct was John Muench: "Joseph Pennell ... once said anything that could be done on paper could be done on stone. He was in error—many more things can be done on stone than on paper."[45] But the hostility of these advocates for stone lithography is unnecessary, and it now seems dated. The controversy over the legitimacy of transfer lithography as an original, rather than reproductive, print process has been displaced by the development of newer technologies and the inevitable wrangles over the originality of the ensuing lithographs.

In the 1970s, the focus was on so-called Mylar lithography, a lineal descendant of techniques that Manet and Degas may have used in the late nineteenth century (nos. 56, 13). The artist draws, usually with pencils but also perhaps with ink or washes, on a sheet of transparent plastic, frosted to catch the pigment. The drawing is laid over a photosensitized lithographic plate and exposed to light. The plate is then processed to produce a printing surface. In the late 1970s, the "inanities of Mel Hunter,"[46] an American realist artist and the principal proponent of Mylar lithography as an original printmaking process, were intemperately attacked in Tamarind Lithography Workshop publications. In countering Hunter's "extravagant claims," Clinton Adams stated, with surprising ignorance, "From Goya to Redon, from Whistler to the present day, countless artists have found the sensuous, responsive surface of the stone to be a full participant in their creative achievements."[47] In fact, Goya's first lithographs (admittedly less than successful technically) were on transfer paper, and Redon and Whistler used it habitually.

Offset lithography, too, has been rejected by lithography's purists, though a printmaker as skilled and attentive to every technical nuance as Jasper Johns has found it valuable as a mechanized extension of transfer paper:

At a certain point, we changed to a[n] offset press which suggested that I could be more extravagant, increase the number of plates to achieve even rather small effects, somewhat in the way one

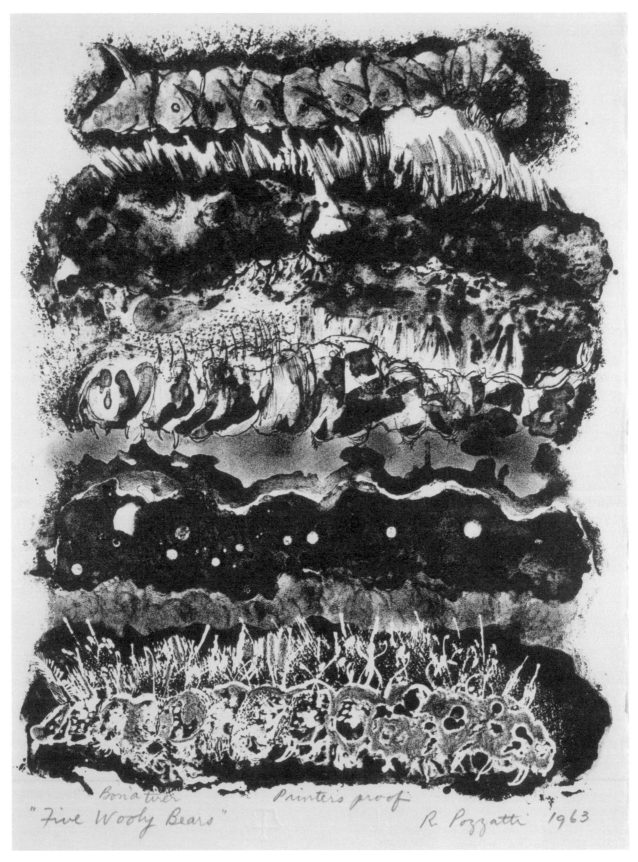

Fig. 42 Pozzatti, *Five Wooly Bears,* no. 74

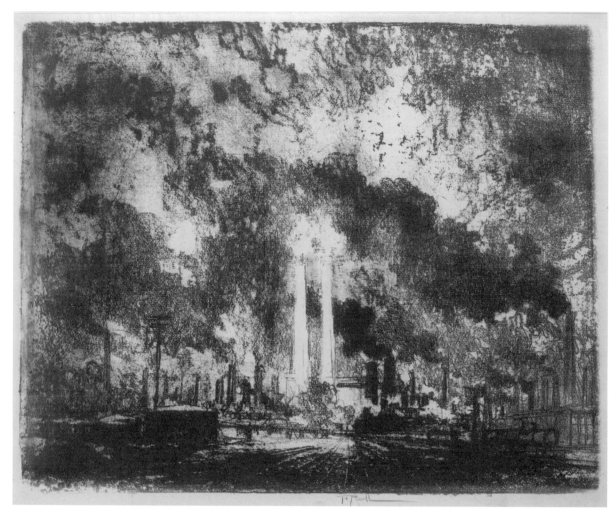

Fig. 43 Pennell, *Oil Refining, Whiting, Indiana,* no. 69

might add brushwork to a painting.... working with this machine ... changed the sense of labor connected with the process.

In printing, one might become interested in something like the use of transfer paper. In working with a hand press, the use of transfer paper would give one the opportunity to have the same image on more than one stone; but using the offset press, the image which exists on one plate can simply be printed onto another plate.[48]

The following description of the synergistic reconciliation of Mylar and offset lithography at one contemporary print studio sounds like the ultimate triumph of the printer and the machine, injected into the artistic process as full equals with the artist:

The offset press had long been banned as too 'mechanical' a device for the creation of original graphic art, but [Kenneth] Tyler's adoption of it ... liberated not only [Frank] Stella but

[David] Hockney too. Tyler Graphics is now well ahead of the field in the development of screenless lithography, a process that enables an artist's drawing on a transparent surface to be transferred to continuous-tone plates....

Yet the author concludes that "[Tyler's] adaptation of drawing materials has allowed Hockney to make color prints almost as spontaneously as paintings or drawings."[49]

And so even the ultimate industrialization of transfer lithography by phototransfer and offset printing returns to the original ideal of the artist's touch, articulated in 1803, only five years after the invention of lithography: "The artist can have many thousand impressions of his drawing..., the first is as good as the last, and each one contains the spirit of the original."[50] It confirms the "gradual perfection" foretold for transfer lithography in 1818 by its inventor, Alois Senefelder.

1. Alois Senefelder, *The Invention of Lithography,* trans. J. W. Muller (London, 1911), 23–24; the original was published in 1818.

2. Ibid., 190–91.

3. Henry Bankes, *Henry Bankes's Treatise on Lithography,* reprinted from the 1813 and 1816 editions with an introduction and notes by Michael Twyman (London, 1976), 15, quoting from the 1816 edition.

4. Quoted in Michel Melot, "The Nature and Role of the Print," trans. Helga Harrison and Dennis Corbyn, in Melot et al., *Prints* (New York, 1981), 98. Melot recognized this ancestor of the photocopy but did not specify that the passage referred to transfer lithography.

5. Beyond the ease with which transfer lithography allowed handwriting to be reproduced, its capacity to reproduce the exact character of handwriting, equivalent to its perfect record of the artist's touch in drawing, gave it a unique application in Muslim cultures, where the long tradition of calligraphic transcription of the Koran had inhibited the development of printing with type. See André Demeerseman, "Une étape importante de la culture islamique: une parente pauvre de l'imprimerie: la lithographie arabe et tunisienne," *Revue de l'Institut des Belles Lettres Arabes* 16, no. 64 (1953): 347–89.

6. Esther Sparks, *Universal Limited Art Editions, a History and Catalogue: The First Twenty-Five Years* (Chicago/New York, 1989), 84, quoting from Judith Goldman, *American Prints: Process & Proofs,* exh. cat., Whitney Museum of American Art (New York, 1981), 85.

7. Susan Rothenberg has said that "working on the stone was too scary—too direct—so I kept working on the [transfer] paper as long as possible"; quoted in Elizabeth Armstrong and Sheila McGuire, *First Impressions: Early Prints by Forty-Six Contemporary Artists,* exh. cat., Walker Art Center (Minneapolis/New York, 1989), 98.

8. See the excellent technical article by John Sommers, "Lithographic Transfer Papers: Alternatives and Procedures," *Tamarind Technical Papers* 1, no. 7 (1977): 81, 83–85, 91. Samples of various papers are included.

9. Quoted in Mark Pascale, "Printmaking (on Everything), Apology to Terry Allen," in Joseph Ruzicka, *Landfall Press: Twenty-Five Years of Printmaking,* exh. cat., Milwaukee Art Museum (Milwaukee, 1996), 24. Both Tamarind and ULAE would eventually fully absorb transfer lithography into their repertoires.

10. Briefly, in a review of an 1896 exhibition of prints by Joseph Pennell, Walter Sickert suggested that it was deceptive to call transfer lithographs "lithographs." Sickert implied that these were merely mechanical reproductions of drawings, and he reminded his readers of Pennell's own published attack on Sir Hubert von Herkomer for describing photomechanical reproductions of his drawings as etchings. Pennell sued the paper in which Sickert's review had appeared, and won damages and court costs. The trial was enlivened by the testimony of Whistler, who had written the introduction to the Pennell exhibition catalogue. In his review, Sickert had attempted to exempt Whistler's own transfer lithographs from his categorical criticism. See Walter Sickert, "Transfer Lithography," *The Saturday Review* 82, no. 2148 (26 December 1896): 667–68, and Elizabeth Robins Pennell, *The Life and Letters of Joseph Pennell* (Boston, 1929), 1:221–23, 307–14.

11. The magazine was promptly shut down by the authorities. See Marie-Hélène Tesnière and Prosser Gifford, *Creating French Culture: Treasures from the Bibliothèque Nationale de France,* exh. cat., Yale University (New Haven/London, 1995), 400, and Elise K.

Kenney and John M. Merriman, *The Pear: French Graphic Arts in the Golden Age of Caricature,* exh. cat., Mount Holyoke College Art Museum (South Hadley, Mass., 1991), 99.

12. "Ainsi, pour une poire, pour une brioche, et pour toutes les têtes grotesques dans quelles le hazard ou la malice aura placé cette triste ressemblance, vous pourrez infliger à l'auteur cinq ans de prison et cinq mille francs d'amende??

Avouez, messieurs, que c'est là une singulière liberté de la prèsse!!"

13. Transfer lithography also facilitated script in the lithograph of a bouquet whose flowers were individually contributed by eight artists participating in an exhibition of still-life paintings at the Terry Dintenfass gallery in 1962 (no. 31). Although the artists drew all the blossoms on a single zinc plate (carted around by Mrs. Dintenfass to their studios), they wrote their signatures onto transfer paper, to be applied to the plate by the printer, Burr Miller. The ease with which eight artists could contribute to the poster, with the effect of rapid and individuated drawing, was of course utterly dependent on the lithographic process.

I am most grateful to Herbert Katzman, William King, and Antonio Frasconi for their memories of drawing the poster. Although Katzman and King remembered transfer lithography as its sole means of execution, Frasconi's circumstantial (and very funny) account of the bouquet's completion on the plate over steaks and drinks at Philip Evergood's studio is probably correct, especially since Frasconi, the driver, remained relatively sober. As King said, in explanation of his poor memory of the lithograph, "Those were my drinkin' days. (And not just *mine,* either)"; letters of 2 June (Katzman), 4 June (King), and 8 June (Frasconi) 1997 to the author.

14. Sickert, "Transfer Lithography" (n. 10 above).

15. See my discussion of graining as a drawing technique dependent on the grain of laid paper, in "The Artist's Touch," in this publication.

16. Margaret F. MacDonald, "Whistler's Lithographs," *Print Quarterly* 5, no. 1 (1988): 25.

17. Whistler consciously adopted antique papers to raise the status, and price, of his lithographs: "I intend to bring up the value of these proofs in lithography—You see already I am giving to them the same *beautiful and rare papers that I use for the etchings....*" (quoted in ibid., 28).

18. Bolton Brown, "Lithographic Drawing as Distinguished from Lithographic Printing," *Print Connoisseur* 2, no. 2 (1921): 148.

19. For discussion of these possibilities, see Jay McKean Fisher, "Manet's Illustrations for 'The Raven': Alternatives to Traditional Lithography," and Pat Gilmour, "Cher Monsieur Clot ...: Auguste Clot and His Role as a Colour Lithographer," in *Lasting Impressions: Lithography as Art,* ed. Patricia Gilmour (London, 1988), 170; Douglas Druick and Peter Zegers, *La Pierre Parle: Lithography in France 1848–1900,* exh. cat., National Gallery of Canada (Ottawa, 1981), 95–96; and Douglas Druick and Peter Zegers, "Degas and the Printed Image, 1856–1914," in Sue Welsh Reed and Barbara Stern Shapiro, *Edgar Degas: The Painter as Printmaker,* exh. cat., Museum of Fine Arts (Boston, 1984), xxxv–xxxix, lxv–lxix.

20. Soft-ground etching can also replicate the texture of the paper used in transposing the artist's drawing onto the grounded etching plate, and artists like Louis-François Françia capitalized on the effect to produce deceptive facsimiles of chalk drawings at the turn of the nineteenth century.

21. Emmanuel Pernoud, *L'Estampe des Fauves* (Paris, 1994), 66.

22. Elizabeth Prelinger and Michael Parke-Taylor, *The Symbolist Prints of Edvard Munch*, exh. cat., Art Gallery of Ontario (Toronto/ New Haven/London, 1996), 208.

23. Werner Spies, "On the Graphic Work," in *Max Ernst: Oeuvre-Katalog* (Cologne, 1975), vol. 1, *Das graphische Werk*, ed. Helmut Leppien, x.

24. Jean Dubuffet, "Notes on Lithographs," *The Lithographs of Jean Dubuffet*, trans. Marthe LaVallée Williams, exh. cat., Philadelphia Museum of Art (Philadelphia, 1964), unpaginated.

25. Germain Hédiard, *Fantin-Latour: Catalogue de l'oeuvre lithographique du maître* (Paris, 1906), 18.

26. Florian Rodari, *Collage: Pasted, Cut, and Torn Paper*, trans. Michael Taylor (New York, 1988), 15.

27. Gilmour, "Lithographic Collaboration: The Hand, the Head, the Heart," in *Lasting Impressions* (n. 19 above), 330.

28. Philip Larson, "Willem de Kooning: The Lithographs," *The Print Collector's Newsletter* 5, no. 1 (1974): 6–7.

29. Hédiard, *Fantin-Latour* (n. 25 above), 19.

30. Degas was quoted by Jacques Emile Blanche, as reported in Druick and Zegers, "Degas and the Printed Image, 1856–1914" (n. 19 above), lxviii. Their section in this catalogue on Degas lithographs, pp. lxv–lxxi, gives an exceptionally clear description of Degas's processes, with reproductions of the successive states of his bathers, pp. 220–52, an essential complement. Degas's statement eerily foreshadows Jasper Johns's sketchbook entry: "Take an object. Do something to it. Do something else to it" (quoted in Riva Castleman, *Jasper Johns: A Print Retrospective*, exh. cat., Museum of Modern Art [New York, 1986], 23). Throughout his career Johns has been equally obsessive in reworking his motifs by actually reworking and transferring his printing matrices.

31. Transfer of negatives or drawings on transparent film using photosensitive coating on the stone.

32. Germain Hédiard, *Fantin-Latour* (n. 25 above), 40.

33. Antony Griffiths, "Starting Again from Scratch: Lithography in Germany between the 1890s and the 1920s," in Gilmour, ed., *Lasting Impressions: Lithography as Art* (n. 19 above), 205.

34. Philippe Burty, quoted in Druick and Zegers, *La Pierre Parle* (n. 19 above), 24. See pp. 6–7 in this excellent catalogue for further remarks about the historical development of transfer lithography at this moment in France.

35. Drawings on glass plates used as negatives to produce photographic prints.

36. From Robaut's preface to *Douze Croquis*, quoted in Loys Delteil, *Le peintre-graveur illustré (XIXe et XXe siècles)* (Paris, 1910), vol. 5, *Corot*, page facing Delteil 19.

37. Druick and Zegers, *La Pierre Parle* (n. 19 above), 7.

38. In conversation with Emily Rauh Pulitzer and then with me, summer 1997, Kelly commented that his Paris printer said Giacometti always used transfer paper, "and if it was good enough for Giacometti...."

39. Quoted in Kristian Sotriffer, *Expressionism and Fauvism* (New York, 1972), 121. See Druick and Zegers, *La Pierre Parle* (n. 19 above), 104, for a discussion of turn-of-the-century albums containing original lithographs and photolithographs, in which the reproductions were presented on a par with the originals. In this exhibition, the genre is represented by a slightly later photolithograph after a drawing by George Grosz (no. 43). The title page of the portfolio from which it comes describes the contents simply as "neun Lithographien."

40. F. Ernest Jackson, "Modern Lithography," *Print Collector's Quarterly* 11, no. 2 (1924): 214.

41. Odilon Redon, *À Soi-Même: Journal (1867–1915)* (Paris, 1985), 130, quoted in Pernoud, *L'Estampe des Fauves* (n. 21 above), 67.

42. Ted Gott, *The Enchanted Stone: The Graphic Worlds of Odilon Redon*, exh. cat., National Gallery of Victoria (Melbourne, 1990), 32. In fact, that catalogue's reproduction of this state (fig. 13) shows a considerable amount of shading. See pp. 42–43, for the use of transfer in the printer's shop to combine proof impressions of Redon's images with their inscriptions.

43. Letter to the author, 10 January 1997.

44. Quoted in Clinton Adams, *American Lithographers 1900–1960: The Artists and Their Printers* (Albuquerque, 1983), 57. Brown, quoting himself quoting Pennell, was citing a passage from his manuscript on lithography. He was under pressure to moderate his language in order to secure publication—another instance of the passions aroused by lithographic practice raised to the level of a moral cause.

45. John Muench, *The Painter's Guide to Lithography* (Cincinnati, 1983), 13. Note that Pennell was referring to drawing per se, as an artistic process, and not restricting his comparison only to drawing for transfer, although transfer lithography was the context in which he was writing.

46. Clinton Adams, "Editorial: On Art and Process," *The Tamarind Papers* 2, no. 2 (1979): 32–33. Despite his fulminations against Hunter, in his editorial, Adams was attempting to separate the criterion of quality from that of technical orthodoxy.

47. Clinton Adams, "Comment," *Tamarind Technical Papers* 1, no. 1 (1978): 5. Adams was responding to Mel Hunter, "Revolution in Hand-Drawn Lithography," *American Artist* 41, no. 423 (1977): 52–59f.

48. Christian Geelhaar, *Jasper Johns Working Proofs*, exh. cat., Kunstmuseum Basel (Basel, 1979), 65, 70.

49. Pat Gilmour, "Kenneth Tyler, A Collaborator in Context," in Elizabeth Armstrong, Pat Gilmour, and Kenneth E. Tyler, *Tyler Graphics: Catalogue Raisonné, 1974–1985* (Minneapolis/New York, 1987), 21–22.

50. Felix H. Man, "Lithography in England (1801–1810)," in Print Council of America, *Prints*, ed. Carl Zigrosser (New York, 1962), 104, quoting an article in Johann Christian Hüttner's *Englische Miscellen* 13, no. 1 (1803).

Checklist of the Exhibition

All works are lithographs without hand-coloring unless otherwise indicated.

A bibliography of the standard catalogues that are cited in the Checklist will be found following the Checklist. Many of these will provide reproductions of works not reproduced in this catalogue.

If no state is indicated for a print, it may be assumed to be from the published edition.

Dimensions are given in centimeters, height before width, followed by the extent or source of the measurement, in parentheses.

All works are in the collection of the Fogg Art Museum, Harvard University Art Museums, unless otherwise indicated. Works with temporary loan numbers (TL) and works from the Busch-Reisinger Museum have been lent specifically for this exhibition. Other loans are on long-term deposit at the Print Department, Fogg Art Museum.

Hyacinthe-Louis-Victor-J.-B. Aubry-Lecomte
French, 1787–1858

1 *The Sistine Madonna,* after Raphael, 1826
 Meyer 7 proof before letters
 79.5 × 54.5 (design)
 Gift of William Gray from the collection of Francis Calley Gray
 G70 [figs. 8, 29]

Lily Blatherwick
British, 1854–1934

2 *Blown Poppies,* c. 1920
 Hand-colored, 28.7 × 20.2 (design)
 Anonymous loan in honor of Lois Orswell
 16.1989

Rodolphe Bresdin
French, 1822–1885

3 *Interior with Peasants from the Haute-Garonne (Intérieur de paysans de la Haute-Garonne),* 1858
 Van Gelder 92 iii/iii

Etching, 15.2 × 11.1 (design)
 Gift of David Becker
 M20662

4 *Interior with Peasants from the Haute-Garonne (Intérieur de paysans de la Haute-Garonne),* 1873
 Van Gelder 92 ii/iii
 15.2 × 11.2 (design)
 Gift of Mrs. Irving M. Sobin
 M14642

Nicolas-Toussaint Charlet
French, 1792–1845

5 *The Flag Defended (Le drapeau défendu),* c. 1818
 La Combe 42
 33.2 × 45.7 (design)
 Gray Collection of Engravings Fund
 G8973 [fig. 24]

Jean Baptiste Camille Corot
French, 1796–1875

6 *The Encounter in the Woods (La rencontre au bosquet),* 1871
 Lithographic crayon, 27.8 × 21.9 (sheet)
 Purchase through the generosity of the Fanny and Leo Koerner Charitable Trust and Ruth V. S. Lauer, in memory of Julia Wheaton Saines
 1998.16 [fig. 39]

7 *The Encounter in the Woods (La rencontre au bosquet),* from *Douze Croquis & Dessins Originaux,* 1872
 Delteil 21 ii/ii
 26.9 × 21.9 (*chine collé* sheet)
 Cynthia and Charles Field Fund
 M23776 [fig. 40]

8 *Sappho,* from *Douze Croquis & Dessins Originaux,* 1872
 Delteil 24 i/ii, proof in *"bistre orangé"*
 22.2 × 28.1 (*chine collé* sheet)
 Gift of Mr. and Mrs. Peter A. Wick
 M14762 [fig. 38]

Louis Jacques Mandé Daguerre
French, 1787–1851

9 *Ruins of the Abbey of Jumièges*, plate 12b from *Voyages pittoresques et romantiques dans l'ancienne France*, vol. 1, *Ancienne Normandie*, 1820
Johnson 58
30.5 × 24.2 (design)
Loan from the Houghton Library, Department of Printing and Graphic Arts
TL36313.1

Honoré-Victorin Daumier
French, 1808–1879

10 *Citizen Auguste Thiers Trying On a New Outfit (Le citoyen Auguste Thiers essayant un nouveau costume)*, from *Actualités, Le Charivari* 114 (26 April, 1850)
Delteil 2004 ii/ii
26.7 × 21.8 (design)
Gift of Melvin R. Seiden
M21988.114 [fig. 10]

11 *The Political One-Man Band (L'homme-orchestre politique)*, 1850
Delteil 1934 unpublished proof
27.5 × 21.9 (design)
Gift of Philip Hofer
M3581

Hilaire-Germain-Edgar Degas
French, 1834–1917

12 *Nude Woman Standing, Drying Herself (Femme nue debout, à sa toilette)*, c. 1891–92
Delteil 65, Reed/Shapiro 61 iv/vi
50 × 28.5 (sheet)
Gray Collection of Engravings and George R. Nutter funds
G8830 [fig. 31]

13 *Leaving the Bath (La sortie du bain)*, c. 1891–92
Delteil 63, Reed/Shapiro 65 i/ii
24.6 × 23 (design)
Loan from the estate of Edouard Sandoz
5.1965

Willem de Kooning
American (born in the Netherlands), 1904–1997

14 *The Marshes*, 1970
Graham 7 trial proof
103 × 72.4 (sheet)

Margaret Fisher Fund
M23398 [figs. 36, 37]

Ferdinand Victor Eugène Delacroix
French, 1798–1863

15 *The Crayfish at Longchamps (Les écrevisses à Longchamps)*, from *Le Miroir* (4 April), 1822
Delteil 37 ii/ii
20 × 30.7 (design)
George R. Nutter Fund
M20049

16 *Macbeth and the Witches*, 1825
Delteil 40 iii–iv/v
32.1 × 25 (design)
Deknatel Purchase Fund
M23370 [fig. 1]

17 *Mephistopheles Appearing to Faust in His Study*, 1828
Brown ink on tracing paper, 21.3 × 16.2 (sheet)
Loan from the Houghton Library, Department of Printing and Graphic Arts
TL36313.2

18 *Mephistopheles Appearing to Faust in His Study*, plate 5 from Johann Wolfgang von Goethe, *Faust*, 1828
Delteil 62 ii/v
26 × 21 (design)
Loan from the Houghton Library, Department of Printing and Graphic Arts
TL36313.3

19 *Royal Tiger (Tigre royal)*, 1829
Delteil 80 iii/iv
32.6 × 42.5 (design)
Gift of Paul J. Sachs
M2154

20 *Tiger Drinking*, c. 1853–55
Robaut 679
Graphite on tracing paper, 25.5 × 33.6 (sheet)
Gift of Grenville L. Winthrop
1942.64

Achille-Jacques-Jean-Marie Devéria
French, 1800–1857

21 *Self-Portrait*, 1830
Beraldi 1
42 × 30.8 (*chine collé* sheet)
Anonymous loan in honor of Michael Wentworth
85.1995 [figs. 6, 28]

Gustave Doré
French, 1832–1883

22 *Poster for "La legende du juif errant,"* 1856
Leblanc p. 378
62.2 × 45.2 (sheet)
Jakob Rosenberg Fund
M21515 [fig. 2]

Jean Dubuffet
French, 1901–1985

23 *Light Decor (Léger décor),* plate 2 from *Textures II,* 1959
Arnaud 379 artist's proof
52 × 38 (design)
Gift of Mr. and Mrs. Ralph F. Colin in honor of
Jakob Rosenberg
M14552

24 *Soot (La suie),* plate 6 from *Entendues, Parois VI,* 1959
Arnaud 439 artist's proof
53.5 × 39.7 (design)
Gift of Mr. and Mrs. Ralph F. Colin in honor of
Jakob Rosenberg
M14601

25 *Rectilinear Traces (Tracés rectilignes),* plate 7 from
Entendues, Parois VII, 1959
Arnaud 440 artist's proof
54.3 × 40 (design)
Gift of Mr. and Mrs. Ralph F. Colin in honor of
Jakob Rosenberg
M14603 [fig. 34]

Gottfried (Godefroy) Engelmann
German, 1788–1839

26 *Old Man Wearing a Turban,* after P. A. Wille *fils,* 1814
Winkler 5 i/ii
47 × 29.5 (sheet)
Anonymous loan
35.1993 [figs. 7, 19]

27 *Plate III,* from *Manuel du dessinateur lithographe,* 1822
Letterpress book with lithographic illustration
22 × 14 (cover)
Loan from the Houghton Library, Department of
Printing and Graphic Arts
TL36313.4

Max Ernst
German, 1891–1976

28 *Elektra,* c. 1935/1939
Spies/Lepien 21 A
33.3 × 25.1 (sheet)
Loan from the Busch-Reisinger Museum,
Association Fund
BR59.1

Ignace-Henri-Jean-Théodore Fantin-Latour
French, 1836–1904

29 *Inspiration,* from *L'épreuve,* 1895
Hédiard 121
26.9 × 22 (design)
Gift of Charles H. Taylor
M2501

Helen Frankenthaler
American, born 1928

30 *Bronze Smoke,* 1978
Harrison 71
63 × 47.3 (stone)
Deknatel Purchase Fund
M20191

Antonio Frasconi
American, born 1919

William Dickey King
American, born 1925

Jacob Lawrence
American, born 1917

Paul Suttmann
American, born 1933

Philip Evergood
American, 1901–1973

Raymond Jennings Saunders
American, born 1934

Herbert Katzman
American, born 1923

Robert Gwathmey
American, 1903–1988

Sidney Goodman
American, born 1936

31 *Bouquet of Flowers* (poster for an exhibition of still lifes
at Terry Dintenfass, Inc.), 1962
66 × 50.5 (sheet)

Gift of Anne MacDougall
M23576

Théodore Géricault
French, 1791–1824

32 *Return from Russia (Retour de Russie)*, 1818
Delteil 12 final state
44.3 × 36 (design)
Purchased with the Print Department Discretionary
Fund and Director's Acquisition Fund, and through
the generosity of Virginia H. Deknatel, David Becker,
Alan Dworsky, Mariot F. Solomon, and Daniel Bell
M23244 [fig. 25]

33 *The Piper*, from *Various Subjects Drawn from Life on
Stone*, 1821
Delteil 30 ii/ii
31.4 × 23.2 (design)
Anonymous loan in honor of Clare I. Rogan
109.1996 [fig. 26]

34 *Lion Devouring a Horse*, 1820–21
Clement 102
Pen and black lithographic ink on prepared "stone
paper," 27.4 × 37 (sheet)
Gift of Mr. and Mrs. Philip Hofer
1960.98

35 *Lion Devouring a Horse*, 1820–21
Delteil 67 ii/ii
23.6 × 35.8 (sheet)
Gift of Philip Hofer
M13687

Conrad Gessner
Swiss, 1764–1826

36 *Cavalry Charge* (first version), from *Specimens in
Polyautography*, 1801
Man 66
23 × 31.7 (sheet)
Anonymous loan in honor of David P. Becker
45.1987 [figs. 3, 18]

Francisco de Goya y Lucientes
Spanish, 1746–1828

37 *The Famous American, Mariano Ceballos (El famoso
americano, Mariano Ceballos)*, from *The Bulls of Bordeaux
(Los toros de Burdeos)*, 1825
Harris 283
305 × 400 (Harris)

Anonymous loan
TL36314.1

38 *Brave Bull (Bravo toro)*, from *The Bulls of Bordeaux
(Los toros de Burdeos)*, 1825
Harris 284
305 × 410 (Harris)
Anonymous loan
TL36314.2

39 *Spanish Entertainment (Diversión de España)*, from
The Bulls of Bordeaux (Los toros de Burdeos), 1825
Harris 285
300 × 410 (Harris)
Anonymous loan
TL36314.3

40 *Bullfight in a Divided Arena (Plaza partida)*, from
The Bulls of Bordeaux (Los toros de Burdeos), 1825
Harris 286
300 × 415 (Harris)
Anonymous loan
TL36314.4

Pierre-Louis-Henri Grévedon
French, 1776–1860

41 *Night (Sleep) (La Nuit [Le Sommeil])*, from *Les Quatre
Parties du Jour*, 1833
Bibliothèque nationale 89
58 × 39.5 (sheet)
Susan and Richard Bennett Fund
M23536 [figs. 16, 17]

Antoine-Jean Gros
French, 1771–1835

42 *Mamluk Chief on Horseback (Chef de Mamelucks à cheval)*,
c. 1817
Beraldi vol. 7, p. 260
36.3 × 27.9 (sheet)
Gray Collection of Engravings Fund
G8344 [fig. 23]

George Grosz
American (born in Germany), 1893–1959

43 *"I will eliminate all who do not consider me master" ("Ich will
alles um mich her ausrotten, was mich einschränkt, dass ich
nicht herr bin")*, plate 1 from *Die Raüber*, 1922
Duckers M V, 1
Photolithograph, 70.6 × 53.8 (sheet)
Louise E. Bettens Fund
M12726

Pierre-Narcisse Guérin
French, 1774–1833

44 *The Idler (Le paresseux)*, 1816
Beraldi vol. 8, p. 6
26.9 × 19.7 (design)
Gift of Mr. and Mrs. Usher P. Coolidge
M10939 [fig. 22]

Charles Joseph Hullmandel
British, 1789–1850

45 *The Art of Drawing on Stone*, 1824
Letterpress book, open to pp. 42–43
28 × 19 (cover)
Loan from the Houghton Library, Department of
Printing and Graphic Arts
TL36313.5

Alfred Jarry
French, 1873–1907

46 *The Debraining Song (La chanson du decervelage)*, sheet
music for Act V, *Ubu Roi*, Theatre des Pantins pro-
duction, 1898
Arrivé 65
35.6 × 27 (folded sheet)
Deknatel Purchase Fund
M21159 [fig. 33]

Jasper Johns
American, born 1930

47 *Skin with O'Hara Poem*, 1963–65
Field 48
55.4 × 85.9 (sheet)
Margaret Fisher Fund
M22251

Reuben Kadish
American, 1913–1992

48 *Untitled*, 1937
43.2 × 58.5 (design)
Margaret Fisher Fund
M23000 [fig. 4]

49 *Untitled*, 1961
Tamarind 314 trial proof
76.5 × 56.5 (sheet)
Margaret Fisher Fund
M22436 [fig. 5]

Ellsworth Kelly
American, born 1923

50 *Locust (Acacia)*, 1965–66
Axsom 52
60.5 × 89.5 (sheet)
Margaret Fisher Fund
M23464 [fig. 41]

James Kelly
American, born 1913

51 *Red Wednesday*, 1953
45.5 × 35.7 (stone)
Margaret Fisher Fund
M22749 [front cover]

Ernst Ludwig Kirchner
German, 1880–1938

52 *Dancer Seeking Applause (Beifallheischende Artisin)*, 1909
Dube 122
38.5 × 33 (design)
Loan from the Busch-Reisinger Museum, purchase
in memory of Louis W. Black
BR59.37

Paul Klee
Swiss, 1879–1940

53 *The Acrobats (Die Akrobaten)*, from *Münchner Blätter für
Dichtung und Graphik*, vol. 1, no. 1, 1919
Kornfeld 71 IIb
28.3 × 22.5 (folded sheet)
Loan from the Busch-Reisinger Museum,
Museum purchase
BR52.9

Käthe Kollwitz
German, 1867–1945

54 *Bread! (Brot!)*, 1924
Klipstein 196 III
50 × 32.9 (sheet)
Loan from the Busch-Reisinger Museum,
Anonymous Gift
BR34.39

Edouard Manet
French, 1832–1883

55 *The Balloon (Le ballon)*, 1862
Guérin 68, Harris 23

48.6 × 62.3 (sheet)
Program for Harvard College Fund
M13710 [fig. 11]

56 *The Raven on the Bust of Pallas Athena (Le corbeau sur le buste)*, from Edgar Allen Poe, *Le Corbeau*, trans. Stéphane Mallarmé, 1875
Guérin 86b, Harris 83d
54.5 × 35.7 (sheet)
Gift of Albert H. Gordon
M22408 [frontispiece]

Marisol (Escobar)
American (born in France), born 1930

57 *Five Hands and One Finger*, 1971
Sparks 11 printer's proof
34.5 × 44.8 (design)
Deknatel Purchase Fund
M22034

Henri Matisse
French, 1869–1954

58 *Crouching Nude with Hands Crossed*, 1906
Duthuit-Matisse/Duthuit 394
45 × 28 (sheet)
Gift of Mr. and Mrs. Peter A. Wick
M15001

Joan Miró
Spanish, 1893–1983

59 *Plate XXIV*, from *The Barcelona Suite*, 1944
Lieris/Mourlot 29 artist's proof
69.9 × 52.7 (sheet)
Gift of the artist
M15200 [figs. 13, 35]

Antoine-Pierre Mongin
French, 1761–1827

60 *Poplars*, 1816
Johnson 2
Counterproof reworked in graphite, 44.4 × 30.9 (design)
Gift in honor of Robert R. Barker, Chairman 1985–1991, from members of the Visiting Committee to the Harvard University Art Museums
M21692

Robert Motherwell
American, 1915–1991

61 *Untitled*, 1965–66
Terenzio/Belknap 24A
63.5 × 51 (sheet)
Deknatel Purchase Fund
M20146

Edvard Munch
Norwegian, 1863–1944

62 *Man's Head in Woman's Hair*, from *The Mirror*, 1896
Schiefler 080a
Woodcut and watercolor, 71 × 67.5 (sheet)
Purchased through the generosity of Lynn and Philip A. Straus, Class of 1937
M20285

63 *Poster for "The Mirror,"* 1897
71 × 53 (sheet)
Gift of Lynn and Philip A. Straus, Class of 1937
M21549

64 *The Brooch (Eva Mudocci)*, 1906
Schiefler 212 later state
65.8 × 52.1 (design)
Loan from Lynn and Philip A. Straus
TL36316

Tetsuya Noda
Japanese, born 1940

65 *Diary: Sept. 1st, '74*, 1974
Fugi Television Gallery 144 artist's proof
47 × 64 (design)
Gift of the artist
M23229 [fig. 12]

Emil Nolde
German, 1867–1956

66 *Self-Portrait with a Pipe*, 1907
Schiefler/Mosel 5 trial proof
49 × 32.2 (sheet)
Purchased through the generosity of W. G. Russell Allen to the Friends of Art, Architecture, and Music
M10004

Joseph Dionisius Odevaere
Belgian, 1778–1830

67 *The Artist Drawing on Stone,* 1816
Johnson 5
34.3 × 25 (design)
Gift of The Kaplan Foundation
M14484 [figs. 20, 21]

Claes Oldenburg
American, born 1929

68 *Braque's Nail,* 1980
Axsom/Platzker 171
62.5 × 47 (sheet)
Gift of Mr. and Mrs. Harry Kahn
M20200

Joseph Pennell
American, 1860–1926

69 *Oil Refining, Whiting, Indiana,* 1915
Wuerth 406
41.8 × 52.8 (design)
Gift of Daniel and Pearl K. Bell
M22937 [figs. 32, 43]

Charles Philipon
French, 1802–1862

70 *Louis Philippe Transforms into a Pear: Sketches Made at the Hearing of 14 November,* supplement to *La Caricature* (no. 56, 24 November), 1831
33.3 × 25.6 (sheet)
Curatorial Study Group Fund
M20145 [fig. 30]

Pablo Ruiz Picasso
Spanish, 1881–1973

71 *Head of a Woman (Tête de femme),* 1945
Mourlot 1
44.1 × 33 (sheet)
William M. Prichard Fund
M13923

72 *Still Life with Stoneware Jug (Nature morte au pot de grès),* 1947
Mourlot 86
50 × 65.5 (sheet)
Gray Collection of Engravings Fund
G8863

73 *Claude,* cover for Fernand Mourlot, *Picasso Lithographs,* vol. 2, 1950
Mourlot 186 (right)
32.3 × 24.8 (sheet)
Transfer from Fogg Museum Library
M12917

Rudy Pozzatti
American, born 1925

74 *Five Wooly Bears,* plate 8 from *Bugs,* 1963
Tamarind 770F *bon à tirer*
76.2 × 55.9 (sheet)
Margaret Fisher Fund
M23450 [fig. 42]

75 *Bugs: Colophon,* plate 10 from *Bugs,* 1963
Tamarind 776 *bon à tirer*
76.2 × 55.9 (sheet)
Margaret Fisher Fund
M23452

Robert Rauschenberg
American, born 1925

76 *Visitation I,* 1965
Foster 29
76.5 × 56.4 (sheet)
Transfer from the Student Graphic Rental Program
M20005

Odilon Redon
French, 1840–1916

77 *"… and his name that sat on him was Death" ("… et celui qui était monté dessus se nommait la Mort"),* plate 3 from *Apocalypse de Saint-Jean,* 1899
Mellerio 176
31 × 22.5 (*chine collé* sheet)
Gift of Philip Hofer
M4259

Johann Christian Reinhart
German, 1761–1847

78 *Stormy Landscape with Shepherd Returning Home (Sturmbewegte Landschaft mit heimeilenden Schäfer),* c. 1820
Feuchtmayr 137 iv/iv
Etching, 11.5 × 15 (plate)
Gift of Belinda L. Randall from the collection of John Witt Randall
R6063

79 *The Herd under the Natural Stone Bridge (Die Herde unter der Felswölbung)*, c. 1820
Feuchtmayr 175
12.7 × 15.7 (design)
Anonymous loan
32.1991

Robert Riggs
American, 1896–1970

80 *Children's Ward*, c. 1940
Bassham 76
36.2 cm. × 48.2 (design)
Susan and Richard Bennett Fund
M23011

Alfred Robaut
French, 1830–1909

81 *Tiger Drinking*, plate 16 from *Eugène Delacroix, Facsimilé de dessins et croquis originaux*, 1st series, 1864
Béraldi 99
26 × 34.5 (*chine collé* sheet)
Loan from the Fine Art Library, Harvard University
TL36315

James Rosenquist
American, born 1933

82 *Zone*, 1972
Glenn 53
70.7 × 71.7 (design)
Margaret Fisher Fund
M22053

Kurt Schwitters
German, 1887–1948

83 *Untitled*, page opening 3 from *Die Kathedrale*, 1920
Schmalenbach 251
22.3 × 14.3 (folded sheet)
Loan from the Busch-Reisinger Museum, Association Fund
BR56.71

David Smith
American, 1906–1965

84 *Untitled* (sculptural forms with a blue background), 1952
Schwartz 35
58.5 × 43.5 (design)

Deknatel Purchase Fund
M22755

Thomas Stothard
British, 1755–1834

85 *The Lost Apple*, 1803
Man 134 ii
31.9 × 22.4 (sheet)
Gray Collection of Engravings Fund
G9051

Johann Nepomuk Strixner
German, 1782–1855

86 *Portrait of a Lady*, after Lucas Cranach, plate 20 from Sulpiz Boisserée, *Die Sammlung Alt-, Nieder-, und Ober-Deutscher Gemälde der Brüder Boisserée und Bertram*, 1823
37 × 28.4 (design)
Gift of Paul J. Sachs
M397

Henri de Toulouse-Lautrec
French, 1864–1901

87 *Woman with a Tray (Femme au plateau)*, from *Elles*, 1896
Delteil 181, Wittrock 157
40.2 × 53
Program for Harvard College Fund
M13500

88 *Woman in Bed: Profile (Femme au lit, profil)*, from *Elles*, 1896
Delteil 187, Wittrock 163
40.5 × 52.2
Program for Harvard College Fund
M13506

Emile-Jean-Horace Vernet
French, 1789–1863

89 *A Young Man Carrying a Lithographic Stone*, 1818
Beraldi 117 proof before letters
15.9 × 19.3 (design)
Anonymous loan
158.1985

Max Josef Wagenbauer
German, 1774–1829

90 *Four Sheep, Three Goats*, plate 3 from *Hausthiere*, 1806
Winkler 22 printer's proof

22.7 × 35.5 (design)
Loan from the Busch-Reisinger Museum, gift of
J. B. Neumann
BR57.55

James Ward
British, 1769–1859

91 *Adonis,* from *Celebrated Horses,* 1824
Proof before letters
33.5 × 44.7 (design)
Gray Collection of Engravings Fund
G8996 [figs. 9, 27]

James Abbott McNeill Whistler
American, 1834–1903

92 *Early Morning,* 1878
Way 7 i/iv
16.6 × 25.9 (design)
Purchased through the generosity of Ruth V. S.
Lauer, in memory of her father, Joseph Bishop Van
Sciver (1861–1943)
M23530

93 *The Beautiful Sleeping Lady (La belle dame endormie),*
1894
Way 69
21.9 × 19.5 (sheet)
Gift of Dr. Denman W. Ross
M751 [back cover]

Joyce Wieland
Canadian, 1931–1998

94 *O Canada,* 1970
57.2 × 76.3 (sheet)
Margaret Fisher Fund
M23426 [fig. 15]

Yukinori Yanagi
Japanese, born 1959

95 *Untitled* (the symbol of Korea and the symbol of
Japan merging), plate 4 from *Hinomaru,* 1991
83.6 × 60.9 (sheet)
Margaret Fisher Fund
M22548 [fig. 14]

Works Cited in the Checklist

Adriani, Götz. *Toulouse-Lautrec: Das Gesamte Graphische Werk.* Cologne, 1986.

Andresen, Andreas. *Die deutschen Maler-Radirer (peintres-graveurs) des neunzehnten jahrhunderts, nach ihren Leben und Werken.* 5 vols. Leipzig, 1878. "Reinhart," 1: 177–352.

Arnaud, Noel, compiler. *Jean Dubuffet Grafik/Jean Dubuffet gravures et lithographies.* Exh. cat., Musée de Silkeborg. Silkeborg, 1961.

Arrivé, Michel. *Peintures, gravures et dessins de Alfred Jarry.* Charleville-Mézières, 1968.

Axsom, Richard H. *The Prints of Ellsworth Kelly: A Catalogue Raisonné, 1949–1985.* New York, 1987.

Axsom, Richard H., and David Platzker. *Printed Stuff: Prints, Posters, and Ephemera by Claes Oldenburg: A Catalogue Raisonné, 1958–1996.* New York, 1997.

Bassham, Ben L. *The Lithographs of Robert Riggs.* Philadelphia, 1986.

Beraldi, Henri. *Les graveurs du XIXe siècle, guide de l'amateur d'estampes modernes.* 12 vols. Paris, 1885–92. "Devéria," 5: 222; "Gros," 7: 260; "Guérin," 8: 6; "Robaut," 11: 202–3; "Vernet," 12: 210–23.

Bibliothèque nationale de France. Cabinet des estampes. *Inventaire du fonds française après 1800.* Paris, 1930–. "Grévedon," 8: 378–96.

Clément, Charles. *Géricault: Etude biographique et critique, avec le catalogue raisonné de l'oeuvre du maître.* 3rd ed. Paris, 1879.

Delteil, Loys. *Le peintre-graveur illustré.* 31 vols., 1906–26; reprint, New York, 1969. "Corot," 5; "Daumier," 20–24; "Degas," 9; "Delacroix," 3; "Géricault," 18; "Toulouse-Lautrec," 10–11.

Dube, Annemarie, and Wolf-Dieter Dube. *E. L. Kirchner: Das graphische Werk.* 2 vols. Munich, 1980.

Duckers, Alexander. *George Grosz: Das druckgraphische Werk.* Berlin, 1979; English ed., 1996.

Duthuit-Matisse, Marguerite, and Claude Duthuit. *Henri Matisse: Catalogue raisonné de l'oeuvre gravé.* 2 vols. Paris, 1983.

Feuchtmayr, Inge. *Johann Christian Reinhart: 1761–1847: Monographie und Werkverzeichnis.* Munich, 1975.

Field, Richard S. *The Prints of Jasper Johns, 1960–1993: A Catalogue Raisonné.* West Islip, N.Y., 1994.

Foster, Edward A., compiler. *Robert Rauschenberg: Prints 1948/1970.* Exh. cat., Minneapolis Institute of Arts. Minneapolis, 1970.

Fuji Television Gallery Co., Ltd. *Tetsuya Noda: The Works, 1964–1978.* Tokyo, 1978.

Glenn, Constance. *Time Dust, James Rosenquist: the Complete Graphics 1962–1992.* Exh. cat., University of California, Long Beach. New York, 1992.

Graham, Lanier. "The Prints of Willem De Kooning: An Illustrated Catalogue of His Editions." *Tamarind Papers* (1988), 11: 11–25.

Guérin, Marcel. *L'oeuvre gravé de Manet.* Paris, 1944.

Harris, Jean C. *Edouard Manet, Graphic Works: A Definitive Catalogue Raisonné.* New York, 1970.

Harris, Tomás. *Goya: Engravings and Lithographs.* Oxford, 1964.

Harrison, Pegram. *Frankenthaler: A Catalogue Raisonné, Prints 1961–1994.* New York, 1996.

Hédiard, Germain: "Les maîtres de la lithographie: Fantin-Latour." *L'Artiste* (1892), n.s., 3: 240–51, 433–57.

Johnson, W. McAllister. *French Lithography: The Restoration Salons 1817–1824.* Exh. cat., Agnes Etherington Art Centre. Kingston, Ontario, 1977.

Klipstein, August. *Käthe Kollwitz: Verzeichnis des graphischen Werkes.* Cat. raisonné by Johannes Sievers. Bern, 1955.

Kornfeld, Eberhard W. *Verzeichnis des graphischen Werkes von Paul Klee.* Bern, 1963.

La Combe, Joseph Félix Leblanc de. *Charlet, sa vie, ses lettres, suivi d'une description raisonnée de son oeuvre lithographique.* Paris, 1856.

Leblanc, Henri. *Catalogue de l'oeuvre complet de Gustave Doré.* Paris, 1931.

Lieris, Michel, and Fernand Mourlot. *Joan Miró lithographe.* Paris, 1972.

Man, Felix H. "Lithography in England (1801–1810)." In *Prints,* ed. Carl Zigrosser. New York, 1962.

Mellerio, André. *Odilon Redon.* Paris, 1913; reprint, New York, 1968.

Meyer, Julius, et al. *Allgemeines Künstler-Lexikon.* 3 vols. Leipzig, 1872–85. "Aubry-Lecomte," 2: 379–82.

Mourlot, Fernand. *Picasso lithographe.* 4 vols. Monte Carlo, 1949–64.

Reed, Sue Welsh, and Barbara Stern Shapiro. *Edgar Degas: The Painter as Printmaker.* Exh. cat., Museum of Fine Arts. Boston, 1984.

Robaut, Alfred. *L'oeuvre complet de Eugène Delacroix.* Paris, 1885.

Schiefler, Gustav. *Verzeichnis des graphischen Werks Edvard Munchs bis 1906.* Berlin, 1907.

Schiefler, Gustav, and Christel Mosel. *Emil Nolde: Das graphische Werk.* 2 vols. Cologne, 1966, 1967.

Schmalenbach, Werner. *Kurt Schwitters.* Cologne, 1967.

Schwartz, Alexandra. *David Smith: The Prints, Catalogue Raisonné.* New York, 1987.

Sparks, Esther. *Universal Limited Art Editions: A History and Catalogue of the First Twenty-Five Years.* Exh. cat., Art Institute of Chicago. Chicago/New York, 1989.

Spies, Werner. *Max Ernst: Oeuvre-Katalog.* Vol. 1, *Das Graphische Werk,* ed. Helmut Leppien. Cologne, 1975.

Tamarind Lithography Workshop, Inc. *Tamarind Lithography Workshop, Inc., Catalogue Raisonné, 1960–1970.* Albuquerque, 1989.

Terenzio, Stephanie. *The Prints of Robert Motherwell,* with *A Catalogue Raisonné 1943–1984* by Dorothy C. Belknap. New York, 1984.

Van Gelder, Dirk. *Rodolphe Bresdin.* Vol. 2, *Catalogue raisonné de l'œuvre gravé.* The Hague, 1976.

Way, Thomas R. *Mr. Whistler's Lithographs: The Catalogue.* London, 1896.

Winkler, Rolf Armin. *Die Frühzeit der deutschen Lithographie: Katalog der Bilddrucke von 1796–1821.* Munich, 1975.

Wittrock, Wolfgang. *Toulouse-Lautrec: The Complete Prints.* 2 vols. London, 1985.

Wuerth, Louis A. *Catalogue of the Lithographs of Joseph Pennell.* Boston, 1931.

Index

Page numbers in **boldface** indicate a
reproduction of the work of art; those in
italic indicate a bibliographic reference by
the cited author.

Académie Royale des Beaux-Arts (France),
 38, 39
Ackley, Clifford S., *34, 59*
Adams, Clinton, *33, 77, 81*
André, Friedrich, 41
Arago, François-Dominique, 13
Armstrong, Elizabeth, *35*
Atelier 17, 34
Athanassoglou-Kallmyer, Nina Maria, 45, *59*
Atthalin, Baron Louis, 59
Aubry-Lecomte, Hyacinthe-Louis-Victor-
 J.-B., 23
 Sistine Madonna, **22,** 23, 56, **57**
Bal, Mieke, *58*
Bankes, Henry, 56, *60*
Bartolozzi, Francesco, 38
Bartsch, Adam, *34*
Baudelaire, Charles, *60*
Benjamin, Walter, 11, *13*
Benoist, Pierre, 56
Benson, Timothy O., *34*
Beraldi, Henri, *34*
Bermingham, Ann, *58, 59*
Bertauts (printer), 54
Bewick, Thomas, 35
Bibliothèque nationale de France, Paris, *34*
Blanche, Jacques Émile, 81
Blatherwick, Lily
 Blown Poppies, 31, 77
Boime, Albert, 38, *58*
Boisserée brothers (Johann Sulpiz and
 Melchior), 56
Bonnet, Louis Marin, 38
Boucher, François, prints after, *38*
Bouchot, Henri, *34*
Bracquemond, Félix, 25
Bresdin, Rodolphe, 24–25
 *Interior with Peasants from the Haute-
 Garonne,* 25, *34*
Brown, Bolton (printer), 12, *13,* 24, *34,*
 62, 77
Brücke, Die, 20, 34
Brugada, Antonio, 33
Bryson, Norman, 58

Burty, Philippe, 81
Cadart, Alfred, 25
Cailleux, Alphonse de, *59*
Cameron, Eric, 61
Carey, Frances, *34*
Caricature, La, 62
Carlson, Victor, *34*
Castleman, Riva, *13, 81*
Chamber of Deputies (France), 13, 48
Charivari, Le, 24
Charlet, Nicolas-Toussaint, 26, 49, 50
 The Flag Defended, **48,** 49
Chu, Petra ten-Doesschate, *58*
Clayton, Timothy, *34*
Clément, Charles, *59*
Conner, Bruce, 27, 35
Constitutionnel, Le, 45, 48
Copley, John Singleton, print after, 53
Corot, Camille, 72
 Encounter in the Woods, 73, **74, 75**
 Sappho, 72, **73**
Cranach, Lucas, the Elder, print after, 56
Crommelynck, Aldo, 27
Cuno, James, *59*
Daguerre, Louis Mandé
 Ruins of the Abbey of Jumièges, 49
Daumier, Honoré, 24
 *Citizen Auguste Thiers Trying On a New
 Outfit,* 24, **25**
 The Political One-Man Band, 24
David, Jacques-Louis, 43, *59*
Dedreux-Dorcy, Pierre Joseph, 50
Degas, Edgar, 26, *34,* 72, 81
 Leaving the Bath, 72, 77
 Nude Woman Standing, Drying Herself,
 64, 65
De Kooning, Willem, 71
 Marshes, The, **70, 71**
Delaborde, Henri, *34*
Delacroix, Eugène, 12, 15, *34,* 50, 54, 58
 Crayfish at Longchamps, 48
 Faust, illustrations to, 54
 *Faust and Mephistopheles in the Harz
 Mountains,* 54
 Macbeth and the Witches, **14,** 15, 54
 *Mephistopheles Appearing to Faust in His
 Study,* 54
 Tiger Drinking, 72
 Royal Tiger, 23, 77

Delteil, Loys, *81*
Demeerseman, André, *80*
Desportes, Jules, 56, *59*
Devéria, Achille, 54–56
 Self-Portrait, 20, **21,** 54, **55**
Devéria, Eugène, 56
Dintenfass, Terry, 80
Doré, Gustave
 Poster for "La legende du juif errant," 15, **16,**
 25–26
Druick, Douglas, *34, 80*
Dubuffet, Jean, 66, *81*
 Rectilinear Traces, 66, **68**
Engelmann, Gottfried (Godefroy), 37, 39,
 41, 49, 50, 54, 56, 58, *59*
 Old Man Wearing a Turban, 20, **21,** 41, **42,**
 58–59
Ernst, Max, 66
 Elektra, 66
Evergood, Philip, 80
Eyerman, Charlotte, *59*
Fantin-Latour, Ignace-Henri-Jean-
 Théodore, 25, 62, 66, 71–72
 Inspiration, 72
Farwell, Beatrice, *59*
Field, Richard S., 31, *35*
Fisher, Jay McKean, *80*
Ford Foundation, 15
Francía, Louis-François, 80
Frankenthaler, Helen, 61
 Bronze Smoke, 20
Frasconi, Antonio, 80
Friedländer, Max J., *33*
Gaultron, Charles-Hippolyte, 33
Gauthier, Maximilien, *59*
Gay-Lussac, Joseph, 13
Geelhar, Christian, *34*
Géricault, Théodore, 12, 50, 53–54, 58, 59
 Dappled Gray Horse, 53
 Piper, The, 50, **52**
 Lion Devouring a Horse, 53
 Return from Russia, 50, **51**
Gessner, Conrad
 Cavalry Charge, **17, 40,** 41
Giacometti, Alberto, 81
Gifford, Prosser, *80*
Gilmour, Pat, 11, *13, 33, 34, 80*
Gilpin, William, 40, 49
Girodet de Roucy-Trioson, Anne-Louis, 56

Goldman, Judith, *80*

Goldstein, Robert Justin, 59

Gott, Ted, *34*

Goya y Lucientes, Francisco José de, 12,
 15, 50, 54, 58, 77
 Bullfight in a Divided Arena, 54
 Caprichos, Los, 54
 Bulls of Bordeaux, 15, 54

Gozlan, Léon
 Aristide Froissart, 61

Graham, Lanier, *33*

Grevédon, Pierre Louis Henri
 Night (Sleep), 31, **32, 33**

Griffiths, Antony, 11, *13*, 34, *72*, *81*

Gros, Baron Antoine-Jean, 43, 45, 48, 59
 Mamluk Chief on Horseback, 45, **47**, 59

Grosz, George
 *"I will eliminate all who do not consider me
 master,"* 81

Guercino (Giovanni Francesco Barbieri),
 prints after, 38

Guérin, Pierre-Narcisse, 43, 48
 Idler, The, 43, **46**

Hamilton, Richard, 31

Hautecoeur, Louis, *58*

Hayter, Stanley William, 27, 34

Haythornthwaite, Philip J., *59*

Hédiard, Germain, *33, 34*

Henry IV (France), 50

Herkomer, Hubert von, *13*, 15

Hess, Thomas B., *33*

Heurtier (early reporter on lithography), *58*

Hind, Arthur M., *58*

Hockney, David, 79

Holbein, Hans, the Younger, prints after, 38

Hüttner, Johann Christian, *33*

Hullmandel, Charles, *34*, 37, *39*, 41, 50

Hunter, Mel, *13*, 77, *81*

Ives, Colta, *59*

Ivins, William M., 11, *13*, 24

Jackson, F. Ernest, 76, *81*

Jarry, Alfred
 Debraining Song, 66, **67**
 Ubu Roi, 66

Johns, Jasper, 27, 77, 81
 Skin with O'Hara Poem, 27

Johnson International, R. S., *59*

Jombert, Charles-Antoine, 20, *34*

Joubert, F. E., 40

Kadish, Reuben, 18, 34
 Untitled (1937), **18**
 Untitled (1961), 18, **19**

Katzman, Herbert, 80

Kelly, Ellsworth, 73, 81
 Locust (Acacia), 73, **76**, 77

Kelly, James
 Red Wednesday, **front cover**, 17, 18, 20

Kenney, Elise K., *80*

King, William Dickey, 80

Kirchner, Ernst Ludwig, 20, 34, 76
 Dancer Seeking Applause, 20

Klee, Paul
 Acrobats, The, 72

Kline, Franz, 17

Knigin, Michael, *35*

Kollwitz, Käthe
 Bread!, 65

Koran, The, 80

Koschatzky, Walter, *13*

Lambert, Susan, *58*

Landseer, John, 40, *58*

Lang, Léon, *58*

Larson, Philip, *81*

Lasteyrie, Charles Philibert de, 41

Legros, Alphonse, 25

Lemercier, Joseph, 24–26

Lithographe, Le, 56

Lithographische Kunstprodukte, 41

Louis Philippe (France), 62

Ludwig (Bavaria), 56

MacClintock, Lucy Marion, 43, *59*

MacDonald, Margaret F., *80*

Man, Felix H., *33, 58*

Manet, Edouard, 25
 Balloon, The, 15, 25, **26**
 Raven on the Bust of Pallas Athena, The,
 frontispiece, 65, 77

Marden, Brice, 27

Marisol (Escobar)
 Five Hands and One Finger, 27

Marx, Roger, *34*

Matheron, Laurent, *59*

Matisse, Henri, 65
 Crouching Nude, 65, 77

Matougues, Pierre Benoist de, *60*

McGuire, Sheila, *35*

Melot, Michel, *80*

Merriman, John M., *80*

Miller, Burr G., 12, *13*, 80

Millin, Aubin Louis, 38, *58*

Miró, Joan, 27, *33*
 Barcelona Suite, 27, 66
 Barcelona Suite: Plate XXIV, 27–28, **29**,
 66, **69**

Miroir, Le, 48

Mitterer, Hermann Josef, 41

Mongin, Pierre Antoine, 41, 43, *59*
 Cours complet d'études du dessin, 43
 Poplars, 43

Motherwell, Robert, 17
 Untitled, 17, 18, 20

Mourlot, Fernand, 69

Muench, John, 77, *81*

Munch, Edvard
 Brooch, The (Eva Mudocci), 66
 Man's Head in Woman's Hair, from
 "The Mirror," 71
 Poster for "The Mirror," 71

Munich Feiertagsschule, 41

Munich Pinakothek, 56

Napoleon Bonaparte, 41, 45, 49, 59

Noda, Tetsuya
 Diary: Sept. 1st, '74, 27, **28**

Nodier, Charles, 49, 50, *59*

Nolde, Emil
 Self-Portrait with a Pipe, 34

Nova Scotia School of Art and Design, 61

Odevaere, Joseph
 Artist Drawing on Stone, The, 43, **44, 45**

Oldenburg, Claes
 Braque's Nail, 31

Parke-Taylor, Michael, *81*

Parmigianino (Francesco Mazzola), prints
 after, 38

Pascale, Mark, *35*

Peirce, Charles Sanders, 37, *58*

Pennell, Elizabeth Robins, *80*

Pennell, Joseph, 62, 65, 76, 80, 81
 Oil Refining, Whiting, Indiana, **65**, 77, **79**

Pernoud, Emmanuel, *81*

Philipon, Charles, 62
 Louis Philippe Transforms into a Pear, 62,
 63, 72

Picasso, Pablo, 27, 69
 Claude, 27
 Head of a Woman, 69
 Still Life with Stoneware Jug, 69

Pinson, Stephen C., *13*

Pollock, Jackson, 18, 34

Pozzatti, Rudy
 Bugs, 77
 Bugs: Colophon, 77
 Five Wooly Bears, 77, **78**

Prelinger, Elizabeth, 66, *81*

Prout, Samuel
 *Series of Easy Lessons in Landscape
 Drawing, A*, 58

Prud'hon, Pierre-Paul, 23, 56

Pulitzer, Emily Rauh, 81

Quotidienne, La, 48

Raphael, prints after, 38, 56

Raucourt, Antoine, 39, *58*

Rauschenberg, Robert, 31–33
 Visitation I, 31–32

Redon, Odilon, 25, 34, 76, 77, *81*
 "… and his name that sat on him was Death,"
 from *Apocalypse de Saint-Jean*, 76–77, 81

Regnault-Delalande, François Leandre, 34

Reinhart, Johann Christian, 24

Rembrandt van Rijn, 26

Reynolds, Sir Joshua, prints after, 50

Ribot, Theodule Augustin, 25

Richardson, Jonathan, Jr., *34*

Riggs, Robert, 15

Riggs, Timothy Allan, *34*

Robaut, Alfred, 72, *81*
 Tiger Drinking, 72

Rodari, Florian, *81*
Rosen, Charles, *59*
Rosenquist, James, 18
 Zone, 18
Rothenberg, Susan, 80
Rouart, Ernest, *34*
Ruskin, John, 17, 33
Saussure, Ferdinand de, *58*
Schnit (lithographer), 59
Schwitters, Kurt
 Kathedrale, Die, 66
Sebeok, Thomas A., 58
Selz, Peter, *35*
Senefelder, Alois, 37, 40, 41, *59*, 61, 79, *80*
Shapiro, Joel, 35
Sickert, Walter, 62, 77, 80
Smith, David, 20, 34
 Untitled, 20, 34
Société d'Encouragement (Paris), 41
Sommers, John, *80*
Sotriffer, Kristian, *33*, *81*
Spadafore, Anita L., *59*
Sparks, Esther, *34*
Specimens of Polyautography, 37, 41
Spencer, Kate H., 50, *59*
Sperling, Louise, *35*
Spies, Werner, *81*
Spink, Nesta, *34*
Stella, Frank, 27, 79

Stothard, Thomas
 Lost Apple, The, 17, 41
Strixner, Johann Nepomuk, 56
 Portrait of a Lady, 56
 Sammlung Boisserée, 56
Tallman, Susan, *34*
Tamarind Lithography Workshop, 18, 27,
 34, 61, 77, *80*
Tàpies, Antonio
 Suite Catalano, Plate 2, 35
Taylor, Baron Isidore Justin, 49, *59*
Tedeschi, Martha, *33*
Tesnière, Marie-Hélène, *80*
Toulouse-Lautrec, Henri de, 12
 Elles, 12
 Woman in Bed: Profile, 12, 13
 Woman with a Tray, 12
Truchat (painter), 59
Tutin, Gaston, 69
Twyman, Michael, 56, *58*
Tyler Graphics Ltd., 79
Tyler, Kenneth E., 17, 27, 79
ULAE (Universal Limited Art Editions),
 32, 61, 80
Vernet, Emile-Jean-Horace, 45, *59*
 Croquis lithographiques, 45
 Young Man Carrying a Lithographic
 Stone, 45
Vincent, Howard P., *34*

Voyages pittoresques et romantiques dans
 l'ancienne France, 49, 59
Wagenbauer, Max Joseph, 41
 Four Sheep, Three Goats, 41
Wahl, Ted, 18
Ward, James, 23–24, 50
 Adonis, **23**, 50, **53**
 Siege and Relief of Gibraltar, 53
Watelet, Claude-Henri, 39, *58*
Wayne, June, 15
Wengenroth, Stow, *34*
Whistler, James Abbott McNeil, 26–27,
 62, 76, 77, 80
 Beautiful Sleeping Lady, The, **back cover,**
 62
 Early Morning, 17, 33
 Nocturne in Blue and Silver, 33
Wieland, Joyce
 O Canada, 28, **31**
Wille, Pierre-Aléxandre, 41
Wilson, Juliet Bareau, *33*
Winkler, Rolf Armin, *58*
Wittrock, Wolfgang, *13*
Yanagi, Yukinori
 Untitled, 28, **30**
Young, William, *59*
Zegers, Peter, *34*, *80*
Zerner, Henri, *59*
Zimiles, Murray, *35*

TOUCHSTONE
200 Years of Artists' Lithographs

*was produced by the Harvard University Art Museums,
Cambridge, Massachusetts; Evelyn Rosenthal, project manager
and editor; Dawn Carelli, copy editor.*

*The catalogue was composed in QuarkXPress using the typeface
Zapf Renaissance Antiqua, designed by Hermann Zapf.
Design & typography by Howard I. Gralla, New Haven,
Connecticut. Duotone reproductions from digital photography by
Peter Bittner, Spring Street Digital. Printed by The Stinehour Press,
Lunenburg, Vermont, on acid-free paper manufactured by
Mohawk Paper Mills, Cohoes, New York.*